WATER COLORS

JOHN HOLDEN

VNR VAN NOSTRAND REINHOLD COMPANY

NEW YORK CINCINNATI TORONTO LONDON MELBOURNE

Published in 1980 by Van Nostrand Reinhold Company
A division of Litton Educational Publishing, Inc.
135 West 50th Street, New York, NY 10020, U.S.A.

16 15 14 13 12 11 10 9 8 7 6 5 4 3 2 1

Library of Congress Cataloging in Publication Data

Holden, John.
 Watercolors.

 1. Water-color painting—Technique.
 I. Title.
ND2430.H64 1980 751.4'22 97-9716
ISBN 0-442-24499-1

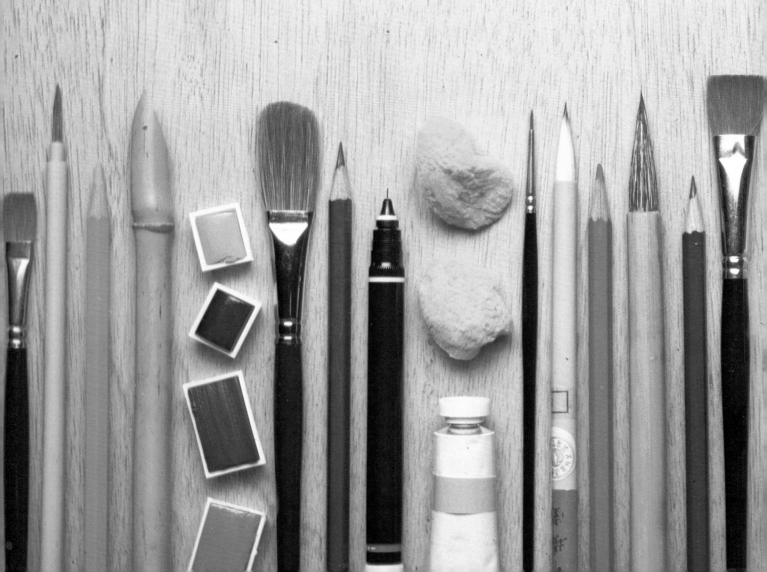

Contents

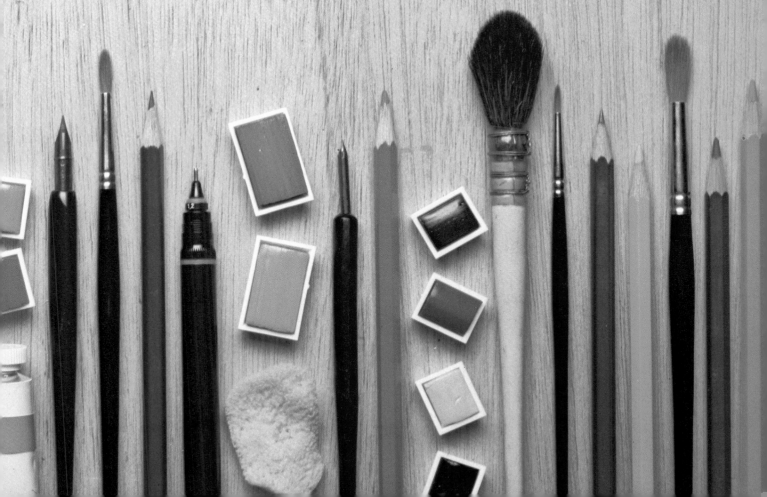

Introduction 1
Materials 17
Handling Color 37
Project: A Landscape 49
Elements of Composition 65
Improving Observation 77
Techniques 109
The Finished Painting 123

Acknowledgements

Albertina Museum, Vienna: 8BR, 96, 104. Courtesy Amon Carter Museum, Fort Worth: 54. Ashmolean Museum: 19, 115. Atkins Museum, Nelson Gallery: 6T. Jake Bell. Artists Cards: 30, 71, (Piccadilly Gallery), 107. Autocar: 77. Courtesy of the Bethlem Royal Hospital and Maudsley Hospital: 81. By courtesy of Birmingham Museums and Art Gallery: 15, 90. Bodleian Library: 8TL. British Library Board: 18. Trustees of the British Museum: 3, (Photo J. R. Freeman) 5, 6BL, 7 (Photo J. R. Freeman), 9, 10, 56, 88, 110. Bronte Museum, Haworth: 91B, 116. Cooper-Bridgeman Library: 78 (Fox Galleries). Reproduced from 'Country Diary of an Edwardian Lady' published by Michael Joseph/Webb & Bower: 92. Fitzwilliam Museum, Cambridge: 80. Glasgow Museum and Art Galleries: 48. Göteborgs Konstmuseum: 27. Cliche Hachette: 40. Hans Hinz: 1L, 13, 94. Hirmer Fotoarchiv: 2. Michael Holford Library: 1R, 5 (British Museum), 67TL (British Museum), 67BR (Lady Hulton, London). Royal Horticultural Society: 95. Hunterian Art Gallery, University of Glasgow: 33 (Birnie Philips Gift), 87. Lefevre Gallery, London: 72. Mansell Collection: 4TL, 112. Marlborough Fine Art Ltd: 58. Frederico Arborio Mella: 8BR (Albertina, Vienna). Peter Meyers: 17. Cliche Musée Nationaux, Paris: 12 (Musée National d'Art Moderne), 47 (Louvre). National Portrait Gallery, London: 99, 102. Norfolk Museums Service (Norwich Castle Museum): 63. Photo Researchers: 85T. Picturepoint, London: 11 (Tate Gallery), 83, 84, 85B. M. Pucciarelli: 66 (Brera Gallery, Milan), 121 (Uffizi, Florence). Sotheby Parke Bernet & Co: 106. Scala: 4BR, 100 (Thyssen Coll. Lugano). The Tate Gallery, London: 11, 16, 31, 42, 60, 70, 74, 103 (photo Chris Barket), 111, 117. Rodney Todd-White, photographer: 24, 51, 52, 75, 82, 120. Victoria and Albert Museum, Crown Copyright: 14, 21, 24, 44, 45, 51, 52, 57, 75, 79 (Angelo Hornak), 82, 86, 105 (Chris Barker). Waddington Galleries, London: 37. Malkolm Warrington: 34/5, 92, 93 (artists sketchbooks: Jane McDonald, David Rose), 109, 113. John Webb, photographer: 31, 32, 60, 74, 111, 117. Whitworth Art Gallery, University of Manchester: 39, 49. Whitney Museum of American Art: 64, 65 (photo: G. Clements), 101. Ziolo: 25. Copyright: '(c) by A.D.A.G.P. Paris 1979': 32. '(c) by S.P.A.D.E.M. Paris 1979': 12, 13, 27, 40, 42, 47, 94. '(c) COSMOPRESS, Geneve and SPADEM, Paris 1979': 67BR, 111.

Introduction

The art of painting dates back many thousands of years, and is one of the primary forms of human creativity and communication. The emotional impact of the early cave paintings at Lascaux in France and Altamira in Spain is still powerful twenty thousand years later. Although there are many theories about how and why these paintings were made, their overwhelming artistic effect is one of vibrant movement, as bison and deer leap and bound across the cave face, heads outstretched, muscles flexed and rippling. As a beginner in watercolour, your approach is closer to this early creative experience than to that of a fully trained modern painter. Perhaps you last painted when you were a child, and you often look back wistfully at the unselfconscious way in which you mixed your colours and water, and laid them on paper with complete freedom and spontaneity.

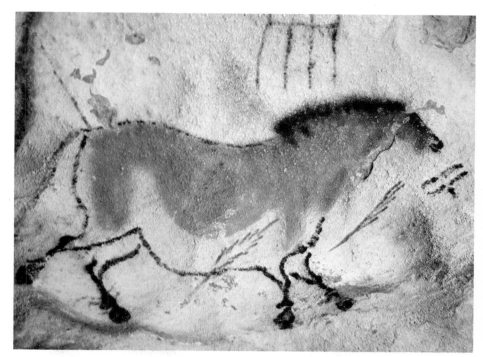

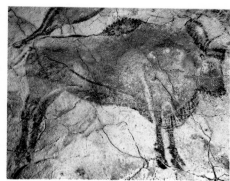

Left: Prehistoric cave paintings such as this magnificent horse, and a bison from the Altamira caves in Spain (below) are among the earliest records of our artistic endeavours.

Since you are neither a cave-dweller nor a child, however, you may feel rather inhibited by your awareness that every art form has its unique skills and special problems. You have probably been made aware of the staggering variety of painting techniques simply by visiting art galleries, or looking at illustrated books on the visual arts. From this comparatively sophisticated standpoint, it is completely bewildering to know where to begin. The purpose of this book is to act as a practical guide to watercolour painting, providing clear information about the equipment you'll need, describing the various technical developments, discussing the possibilities of the medium, and above all, de-mystifying the art itself. As you gain more knowledge in the introductory chapters, you will be encouraged to develop more confidence to start on your own work as soon as possible.

Painting is one of the most satisfying ways of expressing yourself. You look at the world around you with renewed interest, noting colours and textures, and achieving a completely new insight into the most common scenes of daily life. Watercolours in themselves are an ideal medium in which to learn to paint, since you don't need expensive equipment to start, and at the same time, you are able to explore a wide range of painting elements and techniques, including colour sense, composition, the use of various kinds of brushes, and also the values and textures of different varieties of paper. You can also take advantage of

Right: This detail from an Egyptian wall painting shows that beautiful results could be achieved even with a limited range of pigments. The artist is depicting a goose rising from a bed of papyrus.

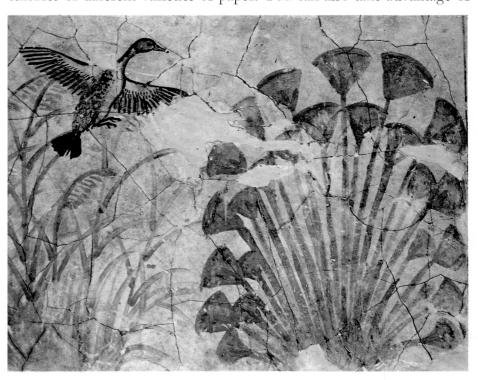

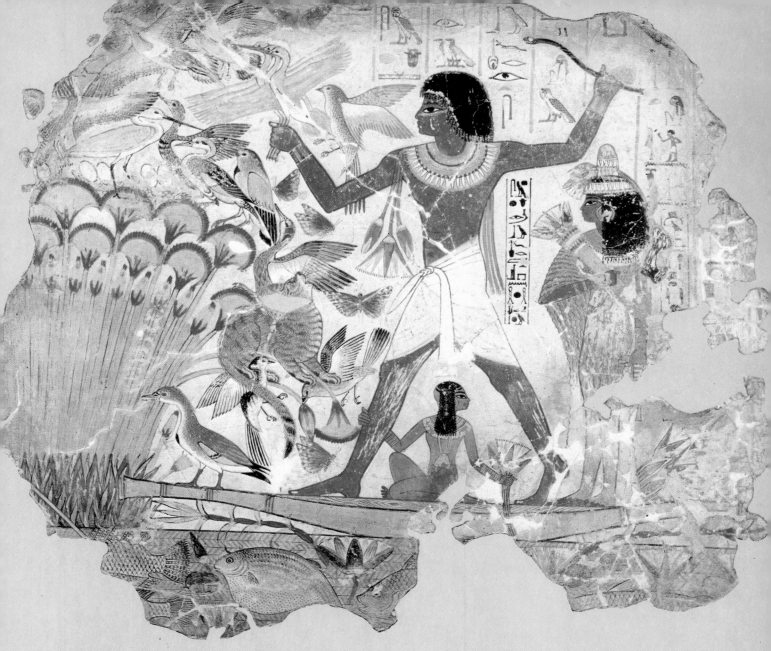

the latest advances in the technological area of paint and binder preparations, which will inspire you to experiment with a really exciting range of texture and colour effects.

What are watercolours?

A great deal of the initial fear you may experience when you approach a completely new skill is caused by some of the special terminology used— almost a secret language in itself, which lends an intimidating aura of mystery, especially when used in the context of art. Perhaps you have heard or read the term *gouache* in connection with watercolours. You

Above: An Egyptian tomb painting c. 1450 B.C. shows a nobleman and his family hunting waterfowl. The style is highly formalized compared to the scene depicted opposite, and incorporates a lot of detail. Notice the hunting cat on the left, as it leaps up to seize a bird.

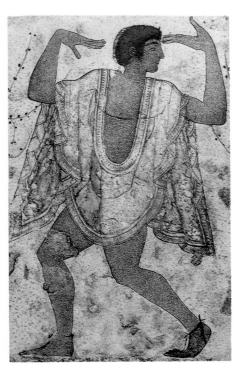

may have even already come across the word *aquarelle*. What do they mean? In fact what are watercolours? One of the most confusing features of any special terminology is that some words are used in more than one sense. For example, let's start with the word watercolour itself. As a term to describe a kind of paint, it simply refers to any pigment or colouring agent which is used diluted with water. It also serves as a classification of a painting technique, for example watercolour as opposed to oil, which might suggest a delicate transparent kind of painting, as opposed to the richly glowing effects associated with oil. In fact the term aquarelle is more accurate to indicate this sense, and is used to describe the kind of watercolour technique which allows the paper or ground of the painting to show through. Aquarelle is less commonly used nowadays however, and the term transparent watercolour is normally employed to make the distinction between this effect as opposed to other kinds of watercolours. The other major kind is known as gouache. This is again a description of a kind of paint as well

Above: A graceful Etruscan dancer adorns the tomb of the Triclinum at Tarquinia (c. sixth century B.C.) Right: An idyllic garden scene painted on an indoor wall of the house of Livia, wife of the Roman emperor Augustus. The tradition of fresco art continued right through to the Renaissance.

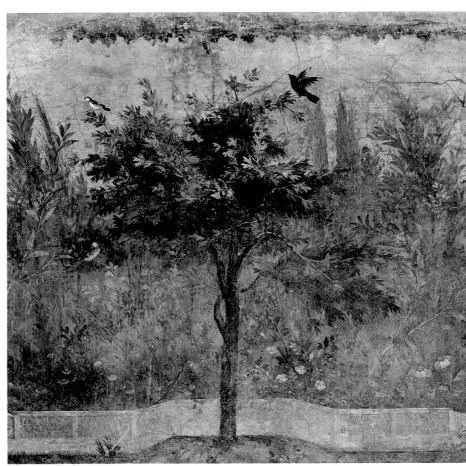

as a technique. Gouache is opaque watercolour paint, and lacks the transparency of aquarelle or transparent watercolour. This is achieved by adding a white pigment to the original pigment. Gouache is also used to describe any painting done with this adapted pigment. Another term you may come across is *body colour,* which is simply another word used to describe gouache—the two are interchangeable. There are various other colouring agents used with water, including inks; however, these will be discussed later on.

Below: Wall paintings often show intimate glimpses of domestic life. This is from Herculaneum, near Pompeii, and depicts a music lesson. It was painted c. first century A.D.

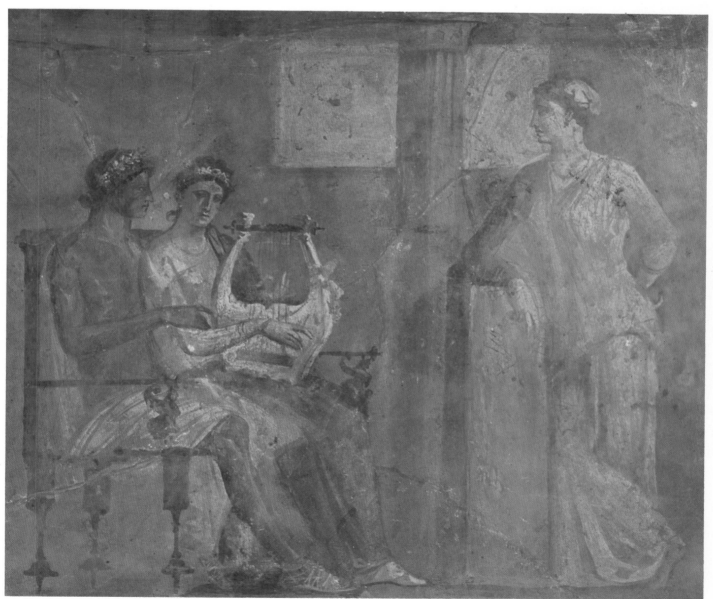

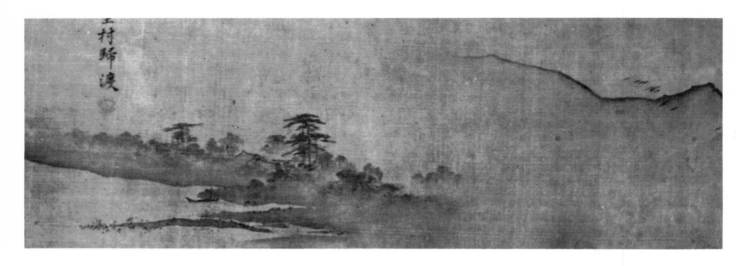

Above: One of the views shown in the early thirteenth century Chinese scroll called Twelve Views from a Thatched Cottage *by Hsia Kuei. The delicacy of the brushwork and the subtle use of sepia ink creates a peaceful and timeless mood.*
Below: The rich colours of this medieval manuscript are enhanced by the addition of gold leaf.

Watercolour past and present

Watercolour is certainly the oldest painting technique, for the simple reason that the methods used to prepare the paint were very simple—the development of oil paint came relatively late in the history of art. The early painters, like those who executed the wonderful wall paintings on Egyptian tombs, relied on pigments found in their natural state, in the earth itself, or in plants. Mediterranean civilization managed to develop a variety of techniques of mixing these basic pigments with different substances, so that a wider range of technical effects was evolved. One of the earliest methods of painting was *buon fresco* in which the pigments were mixed with water and lime, then applied directly onto damp plaster surfaces. A constant problem early painters encountered was that of stabilizing their colours so that they retained their original freshness, and also gained some element of waterproofing. A technique called *tempera* was developed, which in its most pure form used egg yolks to bind the pigments into a sort of emulsion before diluting with water. This gave a much richer quality to colour. Other experiments with tempera used such materials as combined yolk and egg white, fig milk, and several kinds of vegetable juices and gums. Tempera was commonly used between the twelfth and fifteenth centuries. Yet another ingenious technique involved the mixing of pigments with wax, and the final colour was applied in the heated state. This method is known as *encaustic,* and variations of the technique are still used today. Finally, the paints that we most readily recognize as watercolours were developed by mixing the pigments with natural gums, such as gum arabic. Nowadays honey is often added to counteract the brittleness of the gum.

The glories of watercolour painting are displayed in all parts of the world. Chinese and Japanese artists produced the most exquisite effects with transparent watercolour, while medieval artists created glowing

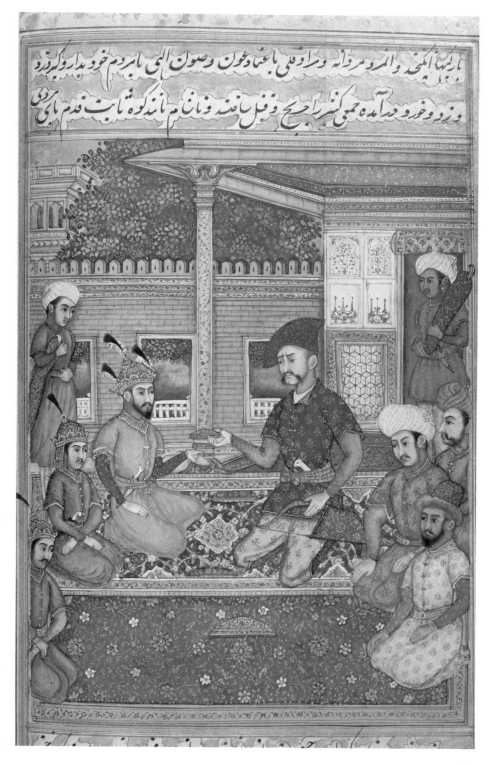

Left: A sixteenth-century Persian painting shows the Shah Abbas welcoming a visiting dignitary. The brilliant colours and flowing calligraphy are beautiful examples of the heights of artistic creativity achieved during the Shah's rule. Many of the colours were made by grinding up precious and semi-precious stones.

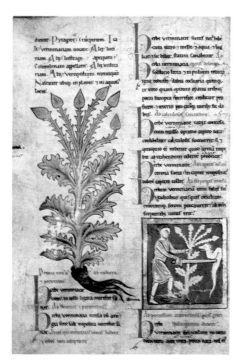

illuminated manuscripts such as those from Kells and Lindisfarne. Persia, India, and of course the Mediterranean countries all used varieties of watercolour to produce wonderful paintings, and later on the medium was used to illustrate books on natural history and travel. By the fourteenth century however, oil paints were thoroughly established as the main colour medium for painters, and watercolours were relegated to a secondary position, occasionally used by Old Masters such as Dürer and Rubens, but only in small and comparatively minor studies.

The Dutch influence and the rise of English watercolourists
In the late eighteenth century however, there was a major development in English watercolour painting. This was influenced by the changing

Above: A very early example of illustrated natural history, this thirteenth-century manuscript shows the herb vervain which was regarded as a cure for all ills.
Right: This fine watercolour of a hare by Albrecht Dürer (1471–1528) is typical of his sensitive and minutely detailed studies of animal and plant life.

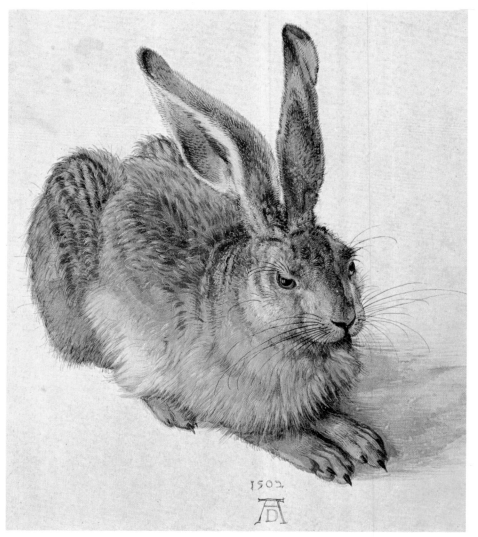

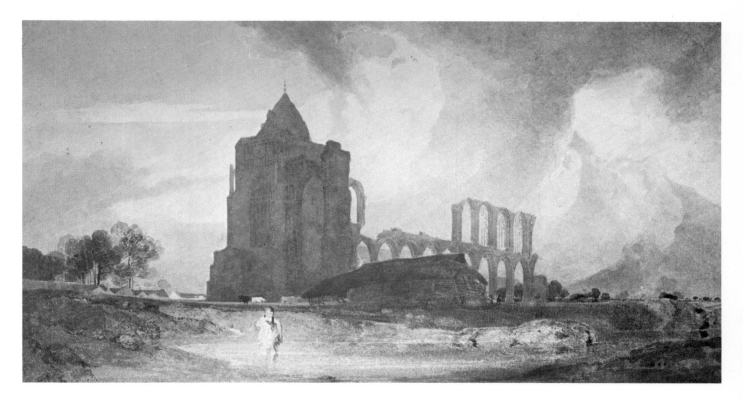

situation in Holland, where the subject matter of painting had been gradually broadening in scope. Before the eighteenth century, much of the work produced by European painters was on a grand scale and supported by heads of state and the Church, with the human figure as the dominant element. The situation in Holland began to alter when the country achieved political independence from the Spanish Netherlands in the sixteenth century, and thereafter developed a highly prosperous mercantile system. During the seventeenth century, a rich middle class of traders emerged, and they demanded a wide range of subject matter from artists, including a continuation of portraiture, still life, interiors, seascape, and most important, landscape, which was to be the key influence on English painting.

A century later, England was in a similar state of growth and prosperity, and during this period there was a unique development in the art of watercolour painting. Under the influence of the Dutch, the subject matter was usually landscape, the figure being incidental, if used at all. An exception to this was William Blake, a visionary artist and poet, who invariably included the human figure in his paintings· Most landscape painters worked from nature on so small a scale that a directly applicable, fast-drying medium was needed. Watercolour was ideally suited for this purpose, and the qualities of the pigment enabled

Above: The gaunt outlines of a medieval abbey against a magnificently washed sky demonstrate the consummate skill of the English watercolourist John Sell Cotman (1782–1842). The foreground of the painting (titled Crayland Abbey) *features an idyllic pastoral scene, however the real focus of the work is the abbey and the skyscape.*

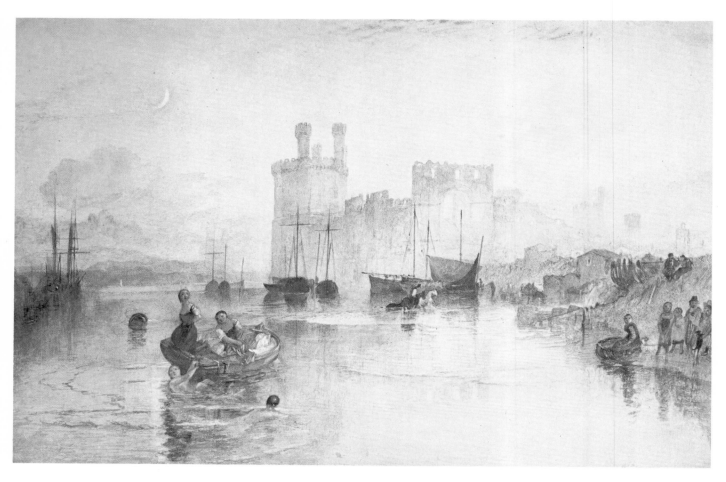

Above: Turner was a brilliant exponent of both the watercolour and oil medium. In this watercolour Caernarvon Castle his genius for painting light through delicate washes, with misty vistas of architecture and sky is fully realized. Again, as with the Cotman on the previous page, the foreground scene is more representational, but is not the real focus of the work.

the artists to capture the subtle colour nuances of the English landscape. Wealthy patrons commissioned fashionable paintings of their homes and the surrounding countryside. This period of English watercolour painting produced some fine, sensitive artists, such as Bonington, Cozens, de Wint, Crome, Cotman and Girtin, to name only a few. They all helped to push the medium to new heights of expression. It was, however, the genius of J. M. W. Turner (1775-1851) which most fully explored the possibilities of watercolour, for he really understood the fundamental directness of application necessary to achieve the finest effects (the only other areas where watercolour has produced such brilliant exponents are China and Japan).

Turner was the first great creative visual mind in Europe to exploit watercolour fully, producing such large, complex works as the view of Caernarvon Castle in North Wales. Often subjects such as these included small figure groups, and these were given a suitable historical title, since there was little popular demand for pure landscapes and the bulk of

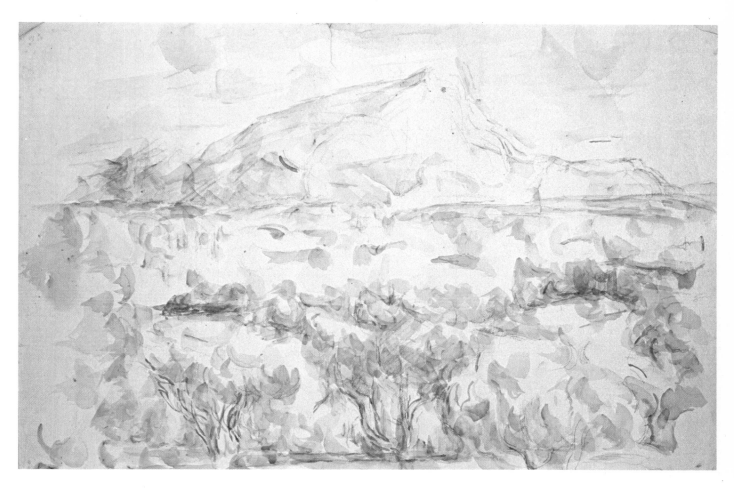

purchasers continued to want mythological or historical subjects. Constable, who was his contemporary, also produced beautiful watercolour landscapes, but it is Turner's appealingly simple studies, particularly those of Venice that are so outstanding. A few brush strokes conjure up a whole atmosphere of extensive space and scale, yet few of these works are more than 30cm (12in) on their longest dimension.

The artistic revolutions

The criteria that had imposed rigid standards of style and subject matter were finally swept away during the successive artistic revolutions of Impressionism, Neo-Impressionism, Cubism, Fauvism, Dada and Surrealism. Consequently, the way was left open for a vast range of innovation in shape, colour, spatial effects and artistic content. Take the revolution in subject matter for example: scenes from mythology and history gave way to café and street life: regal portraits of the rich and aristocratic were supplanted by studies of prostitutes and dancers,

Above: This delicate but authoritative watercolour landscape called Mont Sainte Victoire (*Paul Cézanne*) *is one of sixty versions of the same view. The washes are brushed in with a few strokes, using a restricted range of blues, greens and yellows. Cézanne started using watercolours quite late in life, and produced some exquisite studies in the medium.*

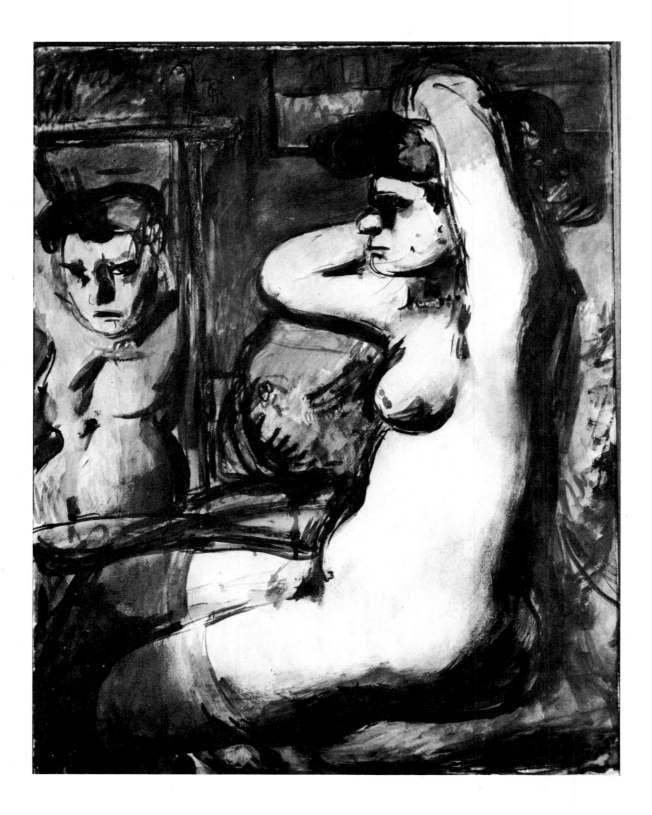

women at their toilet, or at the ironing board. Sedate landscapes were abandoned in favour of railway stations, and urban scenes. The result is that nowadays the painter can choose any subject, whether it be a soup can or a formal portrait.

Although watercolour is not so widely used as oils, a number of major artists have used the medium extensively since the peak period of its popularity in the eighteenth century. At the end of the last century, Cézanne used the medium to achieve a brilliant economy of statement in contrast with the use of really wet, gestural application by Rouault early in this century, or the dynamic, direct application of Dufy. Paul Klee used the medium extensively, sometimes with rich, complex glazing, or else as a simple first-time application of stunning clarity.

In England, the tradition continued to flourish throughout the nineteenth century. There were numerous Victorian artists of repute, though the best loved is probably Samuel Palmer, who produced his finest work before 1840. During this century, artists like Sir Henry Rushbury continued the tradition of Turner's topographical works,

Opposite: The twentieth century revolution in painting styles and subject matter influenced watercolours too, as shown in this highly gestural nude by Rouault called La Fille au Miroir *(1906).*
Below: Artists like Dufy took much of their subject matter from scenes of sporting events such as this work called Racehorses, *painted in a direct, brilliantly colourful style.*

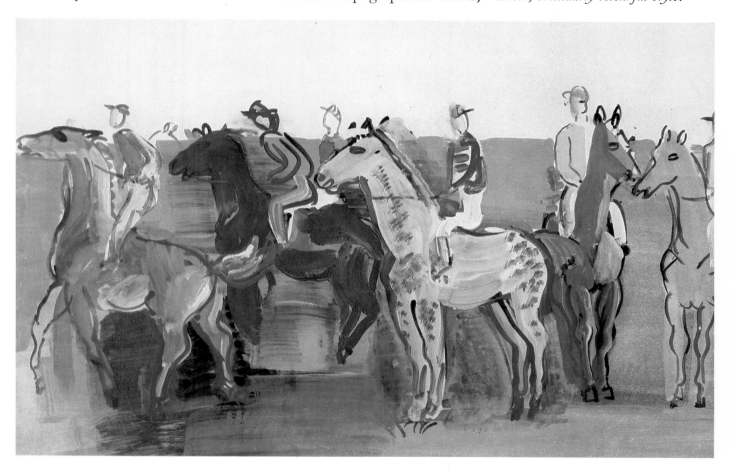

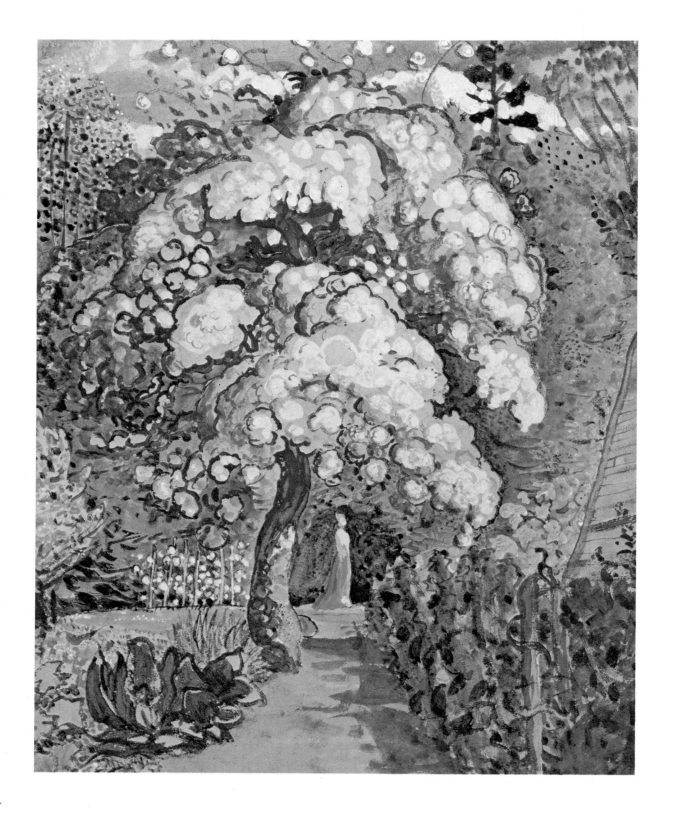

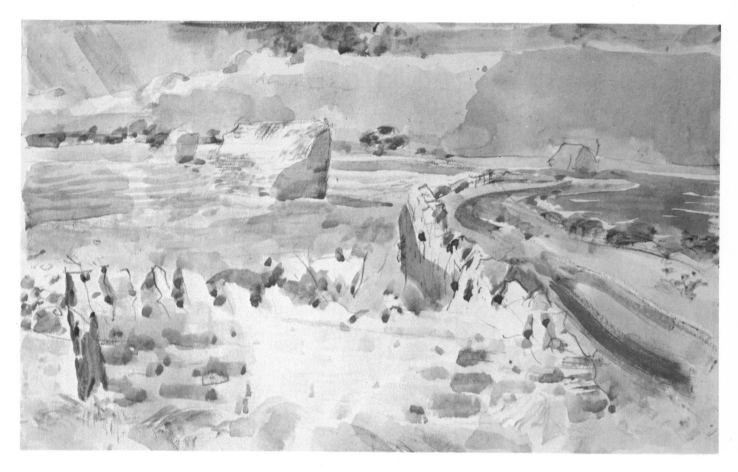

while others, notably Paul Nash and Edward Burra, developed highly particular visions of the world. Nash dealt primarily with landscape, while Burra was more cosmopolitan, drawing great stimulus from city dwellers, such as those of Harlem in New York. During this century, watercolour artists have produced portraits of stunning power, unusual landscapes and richly coloured flower groups, and a new generation continues to explore the medium, often mixing opaque and transparent water paints to achieve beautiful effects.

Given this impressive history, you may be overwhelmed and discouraged at the same time. However, as you are introduced to your materials, you'll soon realize that skills develop through your determination to express your own ideas—there is no single right way to paint, techniques and ideas evolve side by side. Ideas are developed from critical observation of your environment. Regular work will increase your power of observation, and although there are basic skills to learn, after a certain point it is your own vision and imagination that becomes the guiding factor in your progress. Painting, like every artistic activity,

Above: Oxfordshire Landscape *by Paul Nash (1889–1946) shows this artist's typically restrained use of colours—here, sombre greys and yellows. Some of the original sketchwork can be seen showing through.*

Opposite: The English tradition of watercolours developed throughout the nineteenth century. Samuel Palmer's idiosyncratic mystical vision is expressed through his skillful use of gouache in unusual colour combinations. His 'blob' brush technique effectively creates the magical atmosphere of this painting In a Shoreham Garden.

Metropolitan life fascinates Edward Burra. In this watercolour painting Harlem, *he thoroughly exploits the jazzy drama of the New York City environment with its sharp, biting contrasts and dramatic perspectives.*

is highly individual. By viewing and analyzing different shapes and colours, and the way they interact, you will increase your capacity for aesthetic responsiveness. In fact it is unwise to lean too heavily on technical tricks, for each new work should be a fresh challenge. Your eye will gradually become more critical and alert, you will see each experience as a new painting problem—this way you control the medium rather than being overwhelmed by it yourself.

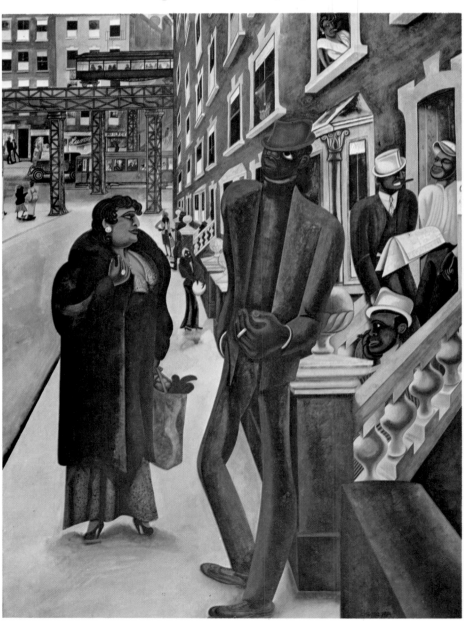

Materials

What do you paint with? There are literally dozens of different brushes, innumerable colours and a huge range of papers and other surfaces available on which to work. Many of the brushes have specific uses and the quality and nature of different waterbased paints have their own idiosyncrasies. Different surfaces can influence a single colour in different ways. The multiplicity of paper presents an alarming problem for the inexperienced. What is the difference between 'hand made' and machine manufactured? What does HP and poundage mean? This chapter will attempt to provide you with simple answers to these questions, indicating which basic materials are required from the massive array available and also how to maintain the quality of those materials once in use.

Brushes

When you first enter an art supply store, you will be faced with a bewildering array of brushes, many of which will have been specially designed for use with different media. Since you are basically concentrating on buying equipment for watercolour work, you'll need to be guided through the maze. Don't be afraid to ask for advice in the store if you are in any doubt. Many artist suppliers are highly trained and will be glad to help you make your selection. Brushes are available in two basic categories—hogs' bristle and hair of different types, qualities and cost. Hair brushes are normally considered to be most suitable for watercolour, and these are available in a wide variety of shapes and sizes. As you handle the brushes, check carefully to see that the bristles or hairs are set securely in the *ferrule,* which is the metal collar holding the hair or bristles and joining them to the brush handle.

Sables, and other hair brushes

As you examine the brushes, especially those made with hair, you will notice that some are much more expensive than others. The most expensive are those made from the guard hairs of the Russian kolinsky sable. These brushes really are magnificent, they are hand-made, and have a superb natural spring. If you use one, you'll discover that it is

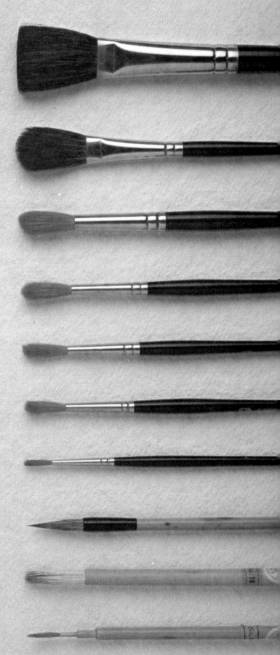

highly sensitive to the brush stroke, and returns to its original shape when dry. But such expensive brushes are not essential for students.

If you are trying to keep down your initial financial outlay, look at the other varieties of hair brushes, many of which are still called sables to distinguish them from bristles. These are made from a wide variety of animal hair, including ox-hair, squirrel, pony and ringcat. The best policy is to spend as much as you can afford for a few good brushes. The really cheap varieties will last for a couple of months, and will then deteriorate. The best brushes, provided they are well looked after, always retain their shape. Whether loaded with paint or not, the curve of the brush should be natural, in order to give you the maximum control when applying your paint.

You will probably also notice that the brushes have differently shaped heads. The basic shapes are round, flat and filbert, the latter being a shape which is in between round and flat. Obviously, these different shapes will produce different kinds of brush strokes. At this point, you are advised to purchase about half a dozen round brushes in a range of sizes. The sizes are numbered so that the smaller brushes are described in low numbers, and the larger in higher numbers. A good initial selection should include a 2 or 3 round for detailed work, and then a range like 5, 7, 8 and 9 for heads which will be suitable for working with larger areas of colour. You may like to buy one flat brush, if so, choose one with a 18mm (¾in) wide head.

Mops

As you work with watercolour paint, you will realize that there are many occasions on which you will need to apply a really large area of colour onto your surface, especially when you are painting on a fairly large scale. For this sort of work you will need a large headed variety of brush called a mop. To be really well equipped, you need both a medium and a large size, although initially the medium size will suffice.

Chinese brushes

Some art supply stores stock Chinese brushes which are usually made from goat or badger hair, and are often set in a bamboo handle. These brushes have very fine points, and have been developed over many generations for the fine calligraphic work so typical of oriental art. One or two of these might be useful, but they are not essential at the beginning.

Hogs' bristle

At the beginning of this discussion on brushes, it was mentioned that hair brushes are traditionally considered to be the most suitable for watercolour work. Brushes made from hogs' bristle have always been

Below: This enchanting study of a kingfisher by Yamanaka Shōnen follows the Japanese tradition of delicate brushwork and glowing, transparent colours. It was painted between 1806–1820.

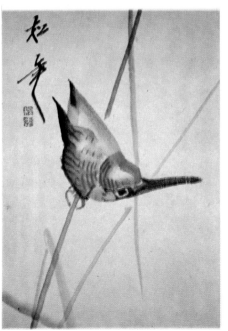

the basic tools for oil painting, since the hairs are very stiff, and are ideal for holding the creamy, thick consistency of oils. These brushes have always been considered too coarse for watercolours. Recently however, manufacturers in Britain have invented a special kind of jelly known as aquapasto which can be mixed with watercolour paints to achieve a really thick consistency, and you can certainly use hogs' bristle brushes with this. This substance should be available internationally in due course, and it provides a fascinating example of how technology changes the scope of painting. More information on the use of aquapasto jelly will be provided later.

Synthetic brushes
In recent years a number of manufacturers have been exploring the possibilities of synthetic fibres for brushes (obviously with the growing

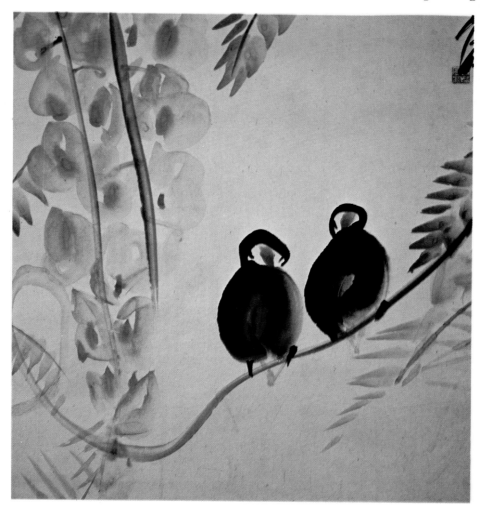

Left: Another exquisite example of oriental line brushwork used in combination with delicate washes. Java Sparrows on a Wisteria Bough *by Ling Feng-Mien.*

19

scarcity of good sable a synthetic alternative has much appeal). Nylon and polyester are the basic materials used. The initial problem seemed to be the lack of holding ability of the head, for unlike natural fibres the synthetic varieties would not absorb paint in any quantity. However, it must be said that recent design improvements in the structural shape of the fibres have improved their holding ability. A wide range of this type of brush both for oil and watercolour painting are now manufactured. They are relatively cheap and hard-wearing, though they do vary greatly in quality depending on the shape of the synthetic fibres used. Their strength makes them ideal for children to use.

Maintaining brushes

Brushes will last and maintain their particular characteristics for years if they are looked after properly. They should be kept in as perfect

Fig. 1 Brushes must be properly maintained, otherwise the heads can be completely ruined, as shown here.

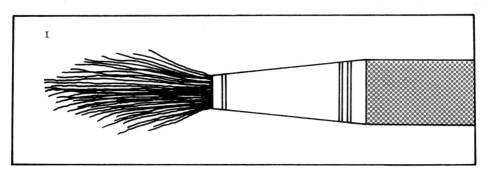

condition as possible, otherwise damaged brushes will seriously affect your work. After any use, rinse brushes thoroughly in warm water and soap, making sure any surplus paint is cleared from the ferrule. Take the soap and warm water and gently work up a good lather in the palm of your hand with the brush. This motion should be gentle so as not to damage the very delicate structure of the head. The brush should then be rinsed, surplus moisture removed and the head shaped to a point between finger and thumb. Stand brushes in a jar, bristles uppermost for everyday storage allowing plenty of space between each brush. An old jug or jam jar is ideal for this purpose. When using brushes always remove them from the water jar after rinsing or they will become damaged. If you have to store hair brushes for any length of time, put some moth repellent in their container, or you might find that your precious brushes have been eaten up.

Transporting brushes

Too often brushes are thrown into boxes, thrust into bags and left without any sort of protection until they are to be used again. Sables are particularly susceptible to damage under these conditions. If the point is

destroyed as in fig. 1 the brush is ruined and will never be able to accomplish the job it was originally designed for. Take note that any brush can be damaged in this way so it is important that some form of protection be devised. This is easily done by making a small tube of some stiff paper secured with adhesive tape, that fits over the head of the brush and onto the handle. High quality sables have this type of covering when purchased. This simple inexpensive device will help to extend the brush's lifespan considerably. As an additional protection during transit, slot your brushes into a cardboard cylinder with one end sealed (a cardboard tube for example) or purchase a special container.

Paints

All paints are made from pigments, which, as was mentioned in the introductory chapter, come from a variety of sources. Pigments are simply the dry colouring agents which are mixed with different kinds of liquid binding materials. The dry pigment may be of natural origin, or produced artificially. They fall into four general categories, according to their source.

Natural mineral colours are often known as 'earth colours' (ochres, umbers, etc). They are mined from the earth, and derive their colour from various iron compounds in the soil, as well as varying amounts of clay, chalk and silica. The qualities of these colours depends very much on what these deposits are, for they produce many forms of colour, transparency and strength. Used since prehistoric times, they are made into all varieties of paints, and produce lively shades of warm browns and yellows.

Factory-made mineral colours are products of the laboratory, and have contributed many new shades to the artist's palette, such as Viridian green and Cobalt blue. Often these colours are equivalents of natural pigments, for example the earth colours mentioned above have been available in artificial form since the middle of the nineteenth century. Today these are generally known as 'Mars colours', and their value lies in the fact that they are freer from impurities than the natural colours.

Natural organic colours are of animal or vegetable origin, for example sepia, which is made from the ink bag of the cuttlefish or squid. These colours tend to be very rarely used, since they bleach out in strong sunlight.

Dyes are different from other pigments in that they dissolve completely in their binding medium. Most dyes are made from complex organic compounds. Some come from natural sources, like Carmine, which is made from an insect. Others, like Alizarin are artificially made, frequently from coal tar. Most dyes have to be mixed with a base, before adding a binder for the colour. These colours are described as 'lakes'.

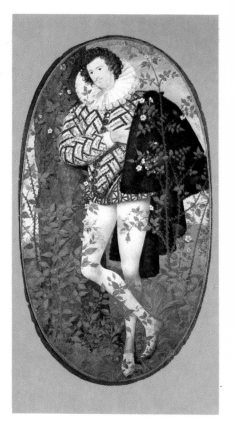

Above: This full length miniature is a delightful example of the work of the Elizabethan painter Nicholas Hilliard.

Pigment colour groups

Before discussing the varieties of ready-made watercolour paints that are available in art supply stores, you should have some background knowledge of the basic colour groups, since all manufacturers have their individual names for colours, as well as great variations in the colours themselves. There are many more pigments in existence than the ones mentioned below, which are usually used for watercolours. In fact, many of them are also used in oils and other media. You will soon be familiar with the various pigments as you paint more.

White pigments

Zinc white, also known as Chinese white, is a brilliant cold white, and is excellent for watercolours. Titanium white, made from titanium oxide has good, fast drying properties.

Yellow pigments

Aureolin is made from cobalt-potassium nitrite, and has an excellent transparent quality. Cadmium yellows and oranges are manufactured from cadmium sulphide, and come in a range of bright, strong tints. Permanent lemon, and Barium yellow are names given to rather weak yellows made from barium chromate. Hansa yellow is a recently developed synthetic lake with a bright, strong colour. Yellow ochre, Gold ochre and Raw sienna are known as the earth yellows, with duller yellow tones. The synthetic equivalents, the Mars yellows, are also included in this group.

Red pigments

Alizarin crimson is a synthetic coal-tar lake, which has transparent properties, and leans toward blue tones. When mixed with Zinc white it produces violet shades. Cadmium reds are similar to the yellows and are available in various shades, in strong, bright colours. Earth reds, and their synthetic counterparts, Mars reds, come in a wide range of shades, from warm, brick reds to cool browns.

Blue pigments

Cerulean blue, Cobalt blue and Manganese blue are all excellent permanent colours, and dry rapidly. Since they are expensive, cheaper versions are made by mixing other blues. Monastral blue, also called Oxford and Winsor blue is a recently devised synthetic lake, very strong in colour, and closely resembling Prussian blue, which is strong in colour also, and transparent. Ultramarine used to be made from grinding the semi-precious stone, lapis lazuli. Nowadays, it is more usually made artificially, though the colour is still quite beautiful, as is French ultramarine.

Green pigments

Chrome oxide greens come in opaque and transparent forms. The former is a strong, mid-green shade, while the transparent kind (also known as Viridian) has a cool tone. Cobalt green is made of cobalt oxides and zinc. It dries rapidly, but has weak tinting properties. Monastral green, also known as Winsor green, is another recently devised synthetic lake, with powerful colour. Terre verte, or earth green is a natural colour, with a weak, grey-green tint.

Purple pigments

Cobalt violet is made either from cobalt arsenate or cobalt phosphate. The first is poisonous, the other quite safe, so check any paint of this derivation to be sure. Alizarin violet, like the crimson, is a synthetic coal-tar lake with transparent bright colour. Ultramarine violet is no longer very popular, though it is a useful tone, and is quite adequate in its tinting strength. Mars violet is a dull, violet brown, and has good, permanent properties.

Brown pigments

Bistre is made from charred beech wood, and has a pleasant warm colour. Sepia can be substituted for this colour, which was very popular with the nineteenth-century watercolourists. Raw and Burnt umbers, are very popular. The former has a warm, rather olive tone, while Burnt umber is a warm, reddish brown. Brown madder is made from one of the Alizarins, and has a deep brown tone with a crimson tinge. Raw sienna is a native Italian earth colour, leaning toward a deep yellow ochre. Burnt sienna is rather orange in tone. Burnt green earth is a burnt variety of Terre verte.

Grey pigments

Charcoal grey, made from various charcoals, is quite valuable for light watercolour washes. Davy's grey is made from powdered slate, and is also good for watercolour. Other grey pigments are mixed. For example Neutral tint is a combination of Alizarin crimson, artificial ultramarine and black. It should only be used in watercolours. Payne's grey is another mixed colour, using a similar mix as neutral tint.

Black pigments

These pigments are usually produced by charring or calcining various materials. Ivory black used to be made from charred ivory chips, though now bones are used. Blue-black comes from calcined wood and other plant sources, and has a slight blue tinge. Lamp black is made from soot obtained from burnt oil. Peach black is from a vegetable base, and has a delicate brown tinge. Vine black is made from charred vine roots.

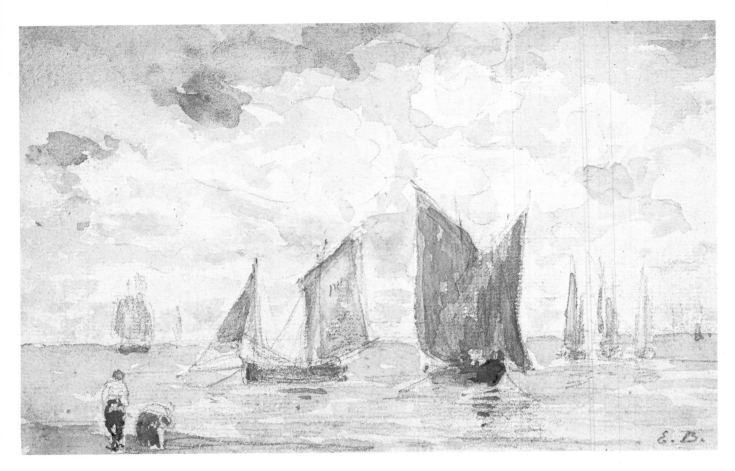

Above: A Summer's Day: Coast Scene *by Eugène Boudin is a fine example of the use of delicate washes and transparent watercolour to achieve a dissolved, airy effect. Notice also the paper ground and the original pencil sketchwork showing through.*

Buying watercolours

Since it is highly unlikely that you are ever going to have to learn to grind and mix your own pigments, as apprentices did under the direction of master painters, you simply have to decide which paints are suitable to buy from art stores. Before considering which colours to choose, it would be wise to look at the various forms of watercolour paints. They fall basically under the main groupings of transparent watercolours and gouache or body colours.

Transparent watercolours

Transparent watercolours can be bought in tubes or pans. Those sold in tubes not only have the usual gum binder, but are also mixed with glycerine to help keep the paint moist. If you buy colours in tubes, remember to keep the tops tightly screwed or else your paint will dry out and harden. If this does happen, you can slit the tube open, and use the hardened colour as you would a pan watercolour. Another hazard is that over a period of time the glycerine separates, and you'll find a

24

transparent, oily liquid seeping from the top of the tube. This should be removed, because it slows down the drying process, however you can compensate by adding a little extra gum arabic, which helps to increase the luminosity of the colour.

As you browse around the store, you'll notice a wide range of colour boxes containing cakes or pans of watercolour in various sizes and shapes. Some boxes are very simple, with about 12 colours, and a white varnished lid with slightly recessed divisions which are meant to be used as mixing palettes. The more sumptuous kinds might have twice as many colours, a special mixing well, a large aluminium palette, its own brushes, and a brush holder. What's more, the whole kit may be packed in a glossy wooden box. Unless you are indulging yourself, your best policy is to use the smaller box, augmented with a selection of tube colours. Try to get a box which you can refill with new pans or cakes of colour; some have a clip mechanism so that you can easily renew the pan. Buy the best ones that you can afford, and economize on materials like mixing palettes. You don't need expensive porcelain ones, although they are very nice. A clean white dinner plate does just as well, and plain white saucers are fine for mixing single colours. If you do raid the china cupboard, remember that you should always mix your colours on a white background, so that it relates to the white surface of your paper. Colourful floral patterns may be fine for your dinner table, but their influence on your colour sense would be disastrous.

There is one form of watercolour colour paint that is sold in hexagonal sticks. These are called architects' watercolours, and although they do not come in a wide range of colours, they are very good quality, and also very economical.

Gouache or body colours

The cheapest variety of these colours are the powder paints usually used by children. They come packed in cans, and are in bright, cheerful colours. The main problem with these is that they tend to flake off when dry, so your painting is ruined. However, if you are really looking at economy as a primary object, you may find that more sophisticated powder colours are helpful. These are sometimes called New art powder colours, and they have a special acrylic medium in which to mix them, this also renders them virtually waterproof when dry. Again, the colour range is fairly limited.

There are various brands of poster paints available in both tubs and tubes. They are excellent in quality, have a good colour range, and maintain their opacity very well.

Designers' colours are the water-based paints used by graphic artists as their name suggests, and have outstanding brilliance of colour, and a stable matt opaque surface when dry. They can also be thinned to a

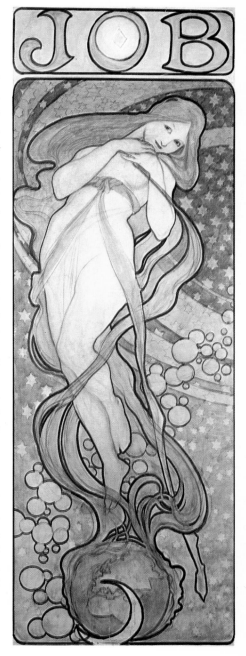

Above: The brilliance of designer's colours are seen at their best in posters. The Czech artist Alphonse Mucha (1860–1933) was a fine exponent of poster art.

fairly transparent film, but even so they are still coarser than transparent watercolours. When you gain some experience with using colours, you may find that you can experiment with combinations of gouache colours like these, and transparent watercolours.

The nearest form of the creamy consistency of oils that you are likely to achieve with watercolours is found in gouache colours, usually used to make a thick paste called an *impasto*. We have already mentioned the new invention, known currently as aquapasto, however. It is this substance that has lessened the restrictions previously encountered by watercolourists. Aquapasto is a virtually colourless transparent jelly, which can be mixed with both transparent watercolours and gouache colours. It even allows you to use a hogs' brush to apply large amounts of thick colour. You can mix any of the watercolours direct, except for the New art powder colours, which should first be mixed to a paste with water before adding the jelly. In all cases add an equivalent amount of the jelly to the paint. You will find that the tube colours are easiest to mix, since you can control the flow. The method of mixing is simple— squeeze the jelly onto a palette, add the colour, and mix with a palette knife. The resulting paste can be applied quite thickly, either with a brush or a palette knife. It will not crack when dry, although you should obviously choose a fairly rigid, coarse surface to hold the weight of the paint.

If you are using layers of wet colours, as you often do with impasto, you can prevent the colours running by spraying on a coat of aerosol

Right: Children have no inhibitions about using paints to express their ideas. They can achieve very graphic results like this using an inexpensive gouache, such as powder paint.

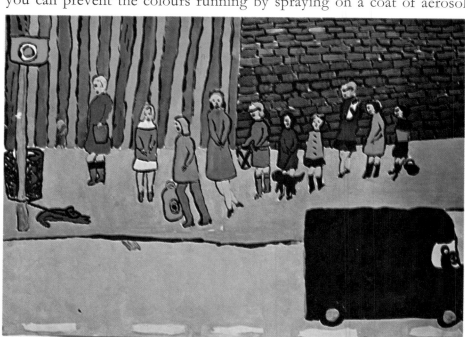

fixative, which you can buy from art supply stores. This applies to other kinds of watercolours, including the transparent ones.

Choosing your basic colours

Every artist has a personal 'core' palette, a range of colours which he can mix to produce a variety of other colours. Since you have been advised

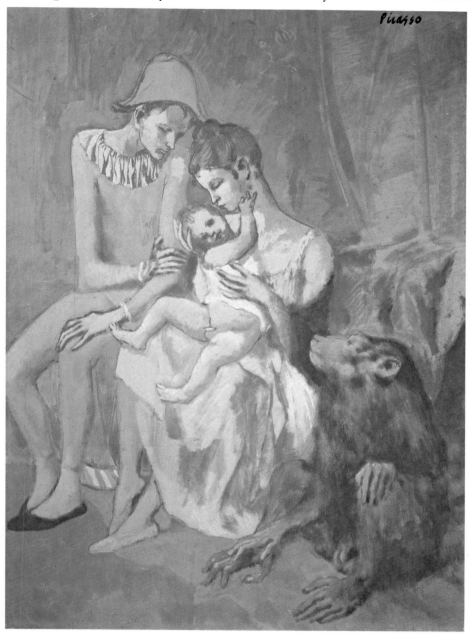

Left: The Acrobat Family *by Picasso* (gouache) *uses the medium in a very subtle manner, and creates a mood of great tenderness.*

to start off with a small, good quality colour box containing about 12 colours, then all you have to do is to check that you have equivalents to the following list of colours.

1. Two yellows, one in a warm Cadmium shade, and another in a paler Lemon colour.
2. A strong, bright Cadmium red.
3. Alizarin crimson.
4. French ultramarine blue.
5. Winsor blue (also called Monastral and Oxford blue).
6. Viridian (the transparent variety of chrome oxide green described in the section on pigment colour groups.
7. Any good purple or mauve colour.
8. Black.
9. White.

Some artists also insist on having good brown shades, but you will soon discover for yourself how many colours you will want to add to your basic range.

Work supports

You will need to support your paper on a board surface, which in itself will require some sort of table or easel on which to rest. Watercolour paint tends to run while being applied, so your drawing board will normally be held in a horizontal position. You could sit in a deep seat with the board resting on your knees, and have a small low table placed nearby which would hold paints, brushes and other equipment. However this is not the most flexible situation in which to paint. An ideal structure would combine a seat, a prop for your board, as well as a table area for equipment. Such structures are made, sometimes known as 'donkeys'; they are usually found in fully equipped artists' studios. The most useful ones for watercolour work should provide at least two heights and four angle adjustments; also, some are provided with wells, which allows for extra storage space for some equipment. These are very expensive however, so consider the following alternatives.

Easels

Sketching easels are compact, light and easily handled. Their telescopic legs ensure stability on uneven ground. There are many to choose from, but try to find one with an adjustable central arm, allowing it to be pivoted into an ideal watercolour working position. Spiked metal shoes are available to fit some easels, to steady them in windy conditions. A simple alternative to these shoes are three wooden or metal spikes and some cord. After setting up the easel, align the spikes with the legs, hammer them into the ground, then bind the spikes and legs together

with the cord. (See fig. 2.) Your easel will be perfectly secure.

A heavier variety of easel, which is really only suitable for indoor work, is called the radial easel. This has a pivot at the juncture of the upright and tripod legs which provides for forward and backward tilting, as well as a central split that allows for an almost horizontal adjustment to the top. This type is an excellent, stable easel.

For indoor work, you can improvise your own support. Use a standard table, and a block of wood to prop up your board—in fact you could use several for different angles. The rest of the table can be used to hold your equipment.

Drawing boards

Boards come in a range of sizes, often with traditional names like 'Royal' or 'Imperial'. Before the introduction of more standard sizings for international purposes, and of course to allow for metrication, board sizes were related to the traditional sizes of paper. In fact the accompanying paper sizes were always a little smaller, so a Royal size in paper would not be the same as the board of that description. To confuse the issue further, many of the finest hand-made papers are still made in the traditional sizes, so you will always have to check carefully that your board is the correct size if you want to use these.

One of the major factors in choosing a board is comfort. You don't want to stretch too far when painting, and also you may have to carry your board around quite a lot when you work outdoors. A good average size would be about 525mm x 650mm (21in x 26in). This is comfortable to work with in a sitting position, for the average length arm will easily reach the top of this size board.

Making your own board

To save money you can make your own board. Always ask a good store to cut the wood to the size you need, making sure that the board is cut with squared edges; check also that it is flat, and has a smooth surface. Since you often need to stretch paper on the board, you must remember to choose a variety that is sturdy enough to withstand the pull of the paper while it is shrinking. (The method of stretching paper is described later in this chapter.) Thus, the wood you choose should be at least 8 ply, and marine plywood is particularly recommended. This material will provide an ideal base, without the danger of glues used in other kinds of wood seeping through and sticking the paper permanently to the board. If you are planning to stretch small sizes of paper, get some small sheets of hardboard as well, since this has sufficient tensile strength to accommodate smaller sizes. Pieces of hardboard are also useful for transporting sheets of paper that have not been stretched. You can simply clip them onto the hardboard.

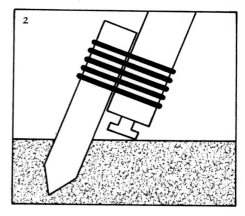

Fig. 2 In order to secure the easel firmly, push pegs into the ground and bind the easel legs to them.

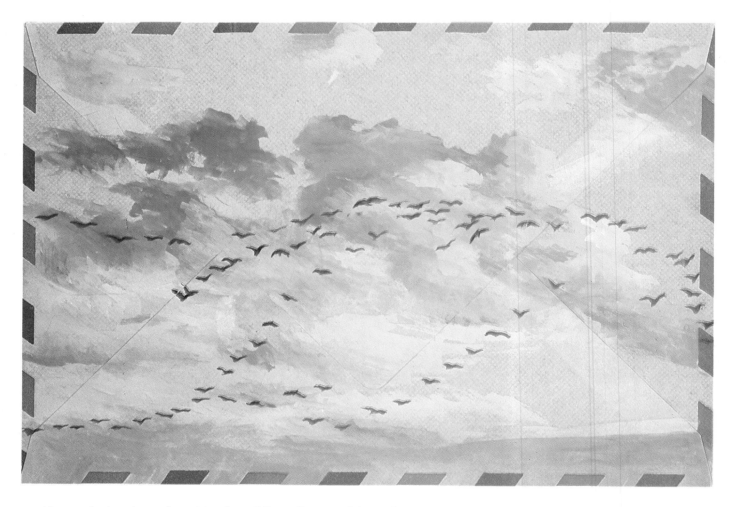

Manufactured boards

Commercially made boards are available in a wide range of size and quality. Buy the best that you can afford, but avoid any with a vinyl surface. These are specially made for projection drawing work, and it will be impossible to stretch paper on them, since the gumstrip used in this process will not stick to them. If you ever have to use very large sheets of paper, you might be able to buy a really large old drawing board from a sale or auction of office equipment. For many, they are too expensive to purchase new, but you might be lucky to spot one second-hand.

Paper

Paper is the most commonly used painting surface for watercolourists. It is available from many different sources and in an almost infinite number of colours, sizes, surfaces and above all else, qualities. What is ideal as a

surface for print, pen, pencil, charcoal or graphite, is not necessarily going to be of any use for watercolour painting.

The finest papers for pure watercolour painting have been traditionally hand-made from linen rags, as have the finest printing papers. Today, however, cotton is the more widely used material. Good printing papers, no matter how beautiful in texture, are not necessarily going to be suitable for painting due to the sizing which is added to all papers during manufacture. There are certain papers, however, that can be used for printing as well as watercolour, depending on the particular results required. The advantage of these papers is they do not yellow in daylight, a critical point when involved with delicate thin transparent watercolours that sometimes barely stain the surface of the paper. In pure watercolour painting all the light comes from the ground (the sheet of paper). Rag papers are extremely expensive for the beginner and a good quality mass manufactured white cartridge paper i.e. drawing paper, should be used instead, at least in the initial stages.

Below: John Sell Cotman's painting Ruin and Cottages, North Wales *is worked on his own hand-made paper. This kind of paper is made by a few specialist craftsmen nowadays, and is highly prized by watercolour painters.*

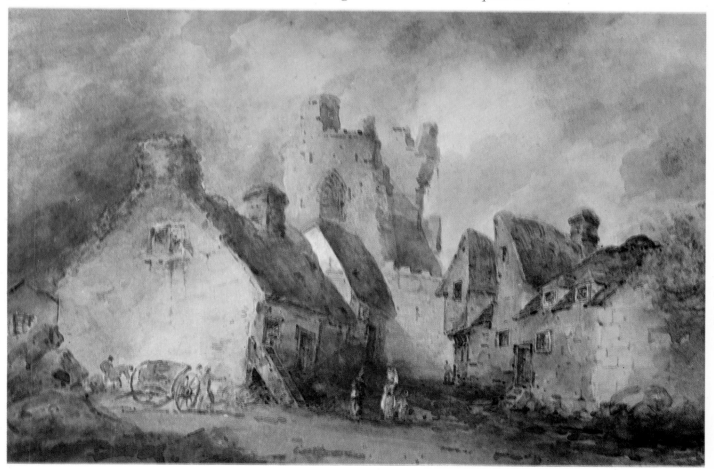

Imperial (standard) measurements

Half Imperial	15 in	× 22 in
Royal	19 in	× 24 in
Super Royal	19¼ in	× 27 in
Imperial	22 in	× 30 in
Elephant	23 in	× 28 in
Double Elephant	26½ in	× 40 in
Antiquarian	31 in	× 53 in

Standard international measurements

A0 841mm × 1189mm	(33⅛ in × 46¾ in)	
A1 841mm × 594mm	(33⅛ in × 23⅜ in)	
A2 420mm × 594mm	(16½ in × 23⅜ in)	
A3 420mm × 297mm	(16½ in × 11¾ in)	
A4 210mm × 297mm	(8¼ in × 11¾ in)	
A5 210mm × 148mm	(8¼ in × 5⅞ in)	

Sizes and weights

In the discussion on drawing boards it was mentioned that their dimensions were traditionally related to corresponding sizes of paper. All these categories have particular names, and since some manufacturers still make papers under these descriptions the accompanying list will be useful. Metric conversions are not supplied, because these papers are only related to Imperial Standard measurements. Always remember to check that the paper size is suitable for your drawing board. Most papers produced today on a mass volume basis are standardized, and an International size range is available as listed in the accompanying chart.

If larger sheets than these are needed, they will have to be bought in cartridge paper, i.e. drawing paper, available in really large sizes.

Papers are also distinguished by their thickness, the weight is quoted per ream (480, 500 or 516 sheets). This term used always to be called *poundage*, e.g. 90lbs per ream. In metric the weight would be quoted at the number of grammes per square metre (i.e. gsm).

Papers have different terms used to describe their surface texture also. *Hot pressed* (HP) paper is ironed to provide a smooth, glossy surface which is excellent for the beginner; *Not pressed* (Not) or cold pressed paper is matt, with a fairly open surface, and is best for pure, transparent watercolour. *Rough* is a heavy grade paper with a really coarse surface, useful for impasto work.

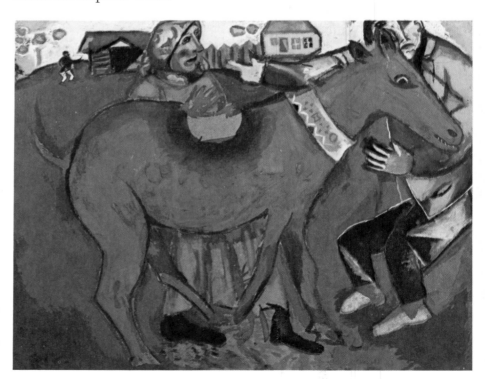

Right: The Green Donkey (*1911*) *by Marc Chagall is painted in gouache on a board ground. Chagall's use of gouache is very appropriate in conveying the fantastical world of his childhood memories.*

Card and board

Various weights and qualities of card or cardboard are available, and are useful grounds for gouache and poster paints. Transparent watercolours can also be used if mixed with aquapasto. The paper surface would probably start to bubble otherwise.

It used to be thought that papers made from cotton were less fine than linen rag varieties simply because of the quality of the cotton itself. Some of today's manufacturers of hand-made paper attribute this misconception to the fact that the medium called 'size', used to control absorbency, was not correctly balanced. If no size were used you would have a blotting paper. So the amount and quality of size is important. Traditionally, a gelatine or hide glue was used for sizing, but today certain hand-made paper manufacturers use a synthetic type, and the quality of paper manufacture is improving. The shredded cotton is passed over a fine mesh and pressed, the size having been added at the pulping stage. This produces excellent paper with the rough edging characteristic of most hand-made papers. The uneven 'deckle' edge is caused by the seepage of pulp between deckle and mould. The various surfaces are the result of careful pressing and drying. Good papers often have a manufacturer's watermark, so you should check to see if your paper has one by holding it up to the light.

The weight of paper is important for the simple reason that the thicker it is the greater the absorption of water before it begins to cockle, i.e. before the surface starts to produce crinkles and bubbles when wet, allow it to dry before continuing to work. A cheap paper cockles almost the moment you apply your paint, making it impossible to have any control over the work because of the undulating surface. The

surface of cheap paper will also tear quickly, and is impossible to work on with any consistency. Obviously the longer you are able to work without interruption, the better. In addition, a paper on which a whole range of techniques can be used has distinct advantages. When using aquapasto as a base, the thicker the paper, the better rigidity it will provide; Not or Rough will provide a tooth (i.e. a coarse surface to hold the paint) similar to that which canvas provides for oil.

It is unwise to use a Rough or Not surface for really fine work: Rough and Not, however, do give additional sparkle to the colour due to the way light flickers across the surface. Begin with a good quality HP paper that allows for fine drawing control. You can buy several varieties of good quality mass-produced papers which only yellow slightly when exposed to sunlight. They are not so expensive that you feel afraid to use them. A possible economic alternative is to purchase the watercolour sketch pads that are available from all artist suppliers. The range of size and quality of paper is considerable and an added advantage is not having to bother stretching the paper. Once confidence has been established, you can start buying much better papers, and these will improve your paintings too.

Besides white paper, a number of tinted papers are also manufactured. For designers' colours and poster paint a white ground is not necessary, but a good quality heavy HP is vital to allow for lengthy uninterrupted work and good results. If used without some of the new additives these paints tend to be vulnerable to cracking, particularly if applied too thickly, so use as rigid a base as possible.

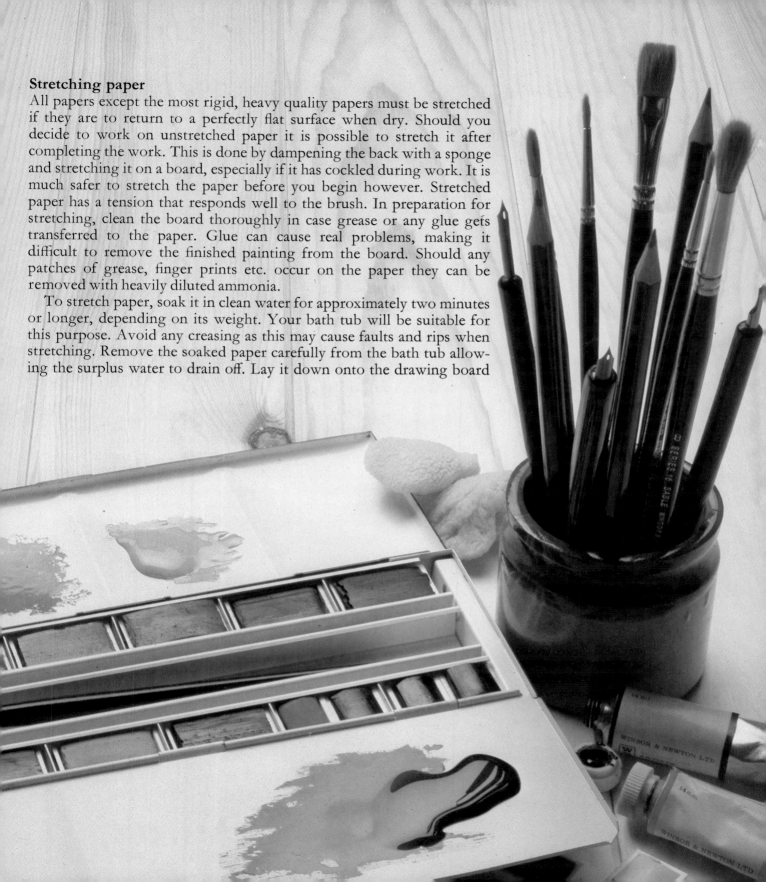

Stretching paper

All papers except the most rigid, heavy quality papers must be stretched if they are to return to a perfectly flat surface when dry. Should you decide to work on unstretched paper it is possible to stretch it after completing the work. This is done by dampening the back with a sponge and stretching it on a board, especially if it has cockled during work. It is much safer to stretch the paper before you begin however. Stretched paper has a tension that responds well to the brush. In preparation for stretching, clean the board thoroughly in case grease or any glue gets transferred to the paper. Glue can cause real problems, making it difficult to remove the finished painting from the board. Should any patches of grease, finger prints etc. occur on the paper they can be removed with heavily diluted ammonia.

To stretch paper, soak it in clean water for approximately two minutes or longer, depending on its weight. Your bath tub will be suitable for this purpose. Avoid any creasing as this may cause faults and rips when stretching. Remove the soaked paper carefully from the bath tub allowing the surplus water to drain off. Lay it down onto the drawing board

making sure the correct face of the paper is upwards. With hand-made papers it is relatively easy to see the right surface on which to work—in fact you can use either—but with some of the good, smooth finished mass manufactured types, it is difficult. Look carefully before placing it in the water and you will notice that one surface has a fine orderly texture on it; that is the back. Gently wipe the surface with a clean, soft dry cloth eliminating any bubbles as you would when wallpapering, then quickly lay a 5cm (2in) gumstrip around all four sides with approximately 18mm ($\frac{3}{4}$in) on the paper and 42mm ($1\frac{1}{4}$in) on the board. Avoid immersing the gumstrip in water, just moisten with a sponge. Leave the board flat to ensure even drying. If drying is uneven, and this easily occurs if the board is stood on end, the moisture drains from the top, allowing the top to begin tensioning as it dries. Meanwhile the heavy moisture content at the base will keep the gumstrip wet and not allow it to glue firmly to the paper. As the uneven drying continues the bottom edge often separates from the gumstrip. If this happens, you must start again with fresh paper. The paper will always cockle during drying but as long as it was flat when the gumstrip was attached, it will dry and tension into an immaculate flat surface.

Storing paper

As paper is so expensive, it is necessary to provide adequate storage where it will be completely free from dust, damp and light. Ideally it should be stored in a plan chest which has large, flat drawers. Wrap it in brown paper to keep off dust, or store in a portfolio. Never roll paper. It damages the structure. If storing vertically, support it with a board, but a horizontal position is preferable, since this provides the most secure all-round protection for your paper.

Other equipment

You will need several other items to add to your basic equipment. Buy a selection of pencils (HB, B, and 2B), also some pens with different sized nibs for fine work; a box of paper clips, a really soft rubber eraser; a small natural sponge; an aerosol spray fixative, which is used to prevent colours running into each other; a matt varnish, which will provide good protection for your finished painting, and which can be applied either in aerosol form, or with a brush. If you intend to use a brush for this purpose, buy a soft, flat hogs' bristle with a 2.5cm (1in), 5cm (2in) or 7.5cm (3in) head.

Watercolour work will require lots of clean water, which can be kept in large screw-topped coffee jars. Also keep a supply of clean absorbent rag and rolls of paper kitchen towels. In order to add gloss and transparency to your colours, you can buy additional gum arabic, which is also available in a more liquid form as gum water.

Handling Colour

The use of colour is one of the most vital skills which the budding artist must acquire. The aesthetic appeal of colour is more direct and immediate than either the form or content of a successful painting. A painting in which the composition is dull but the colours are vibrant and interesting is more likely to be judged a 'good' painting than one where the formal arrangement is well executed but the colours badly used. In its simplest terms, the act of painting is mainly concerned with the use of colour. Some paintings, particularly the modernist abstract works, are 'about' colour and nothing else. How can a painting be 'about' colour? One of the reasons is that colours, particularly in the natural world, have a life of their own. They react to light, distance and movement in multifarious ways. They also react to each other. Colours also,

Below: This attractive abstract gouache titled December V *1973 by Patrick Heron demonstrates a confident use of strong primary colours.*

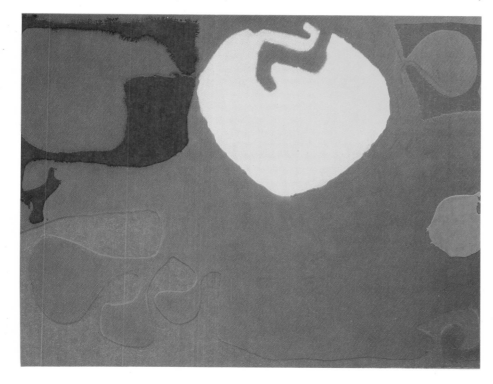

of themselves, evoke emotions, sometimes intense emotions, in the people who are looking at them. Certain combinations of colours can induce sensations of almost physical repugnance, others of blissful pleasure.

Symbolic meanings

In addition to their purely physical impact, colours have meanings which can be, but are not necessarily, related to their visual quality. These symbolic associations are generally culturally derived and can change over time, from one society to another, and even from one person to another. In the West, white is usually taken to mean purity; in certain Eastern countries it is the colour of mourning and death, whereas, in the West, black and sometimes violet or purple are the funereal colours. Purple is also associated with royalty, as is, for obvious reasons, gold. Black can mean 'mystery', 'sophistication' and 'evil', as well as 'death'. Red is the colour of excitement and danger and is, therefore, appropriately used in road signs as a 'stop' or warning sign. For the same reasons, primitive tribesmen still decorate themselves with red, symbolizing strength. Green, the 'go' sign, is a restful, soothing colour. Recent research has shown that green does promote actual physical changes in the body; it is 'easy on the eye'.

These traditional associations of colour can be manipulated by the artist to control or create responses to his paintings. Our reactions to things are influenced by notions of what is the 'correct' colour for various objects. By turning these notions upside down and using the 'wrong' colours in a shocking or unusual way it is possible to convey a subtlety of meaning that would be difficult to achieve in any other way. Consider for example, the impact of a bride in a black wedding dress, or a green fried egg. There are no rules of colour which cannot readily be broken effectively. However there are a number of practical guidelines to do with the selection, mixing and handling of colour which the beginner will find useful.

What is colour?

There are a number of terms which artists use when referring to colour and some which indicate the various properties or attributes that colours possess. Unfortunately there is no general agreement on the precise meaning of these terms and many of them are used loosely or interchangeably so that their meanings overlap or coincide. However, for the purpose of this book the following definitions will suffice.

Hue is the actual colour itself. In everyday terms it relates to the name of the colour, in other words, it means 'red' as opposed to 'green', or 'yellow' as opposed to 'blue' or 'purple'. A tomato is red; red is its hue. *Tone* refers basically to the lightness or darkness of a colour. The

easiest way to grasp the idea of tone is to imagine a colour photograph reproduced in black and white. Some of the distinctions between areas of the picture will have disappeared. This is because, although the colours are different, the tonal value is the same.

Brilliance means the extent to which the colour glows or shows up.

Intensity indicates the strength or richness of a colour.

Shade and *tint* are descriptions of variations in the full strength of a 'normal' colour. Strictly speaking, if it is lighter it is a tint; if it is darker it is a shade.

Left: In his study Trees at Harrow, *Cotman has juxtaposed an unusual combination of colours to produce a clean, fresh effect.*

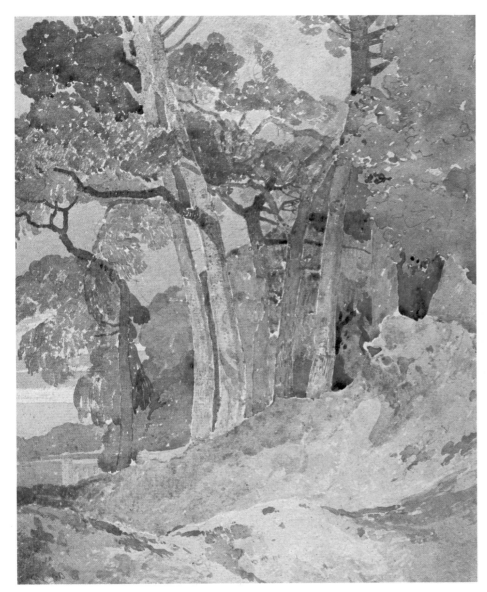

Warmth and *coldness* are elusive terms. Generally warm colours are those which seem to approach you, like reds and oranges. Cool colours are those which tend to recede, like blues.

Choosing colours

The wealth and variety of colours available to the artist today can only be bewildering to the beginner. The confusion is further compounded by the fact that different manufacturers frequently use quite different names to describe the same colours, and also the same names to describe different colours. What is called Magenta by one manufacturer may be quite different from a paint of the same name made by someone else. The temptation for the beginner, in the first flush of enthusiasm for the art, is to buy far too many colours, and to be seduced by those with appealing evocative names like 'Primrose yellow' or 'Forget-Me-Not blue'. In fact the colour box of a professional will almost always contain

Below: An oriental riot of colours, this painting by Bakst for the set of Scheherezade still maintains an overall control over the design scheme.

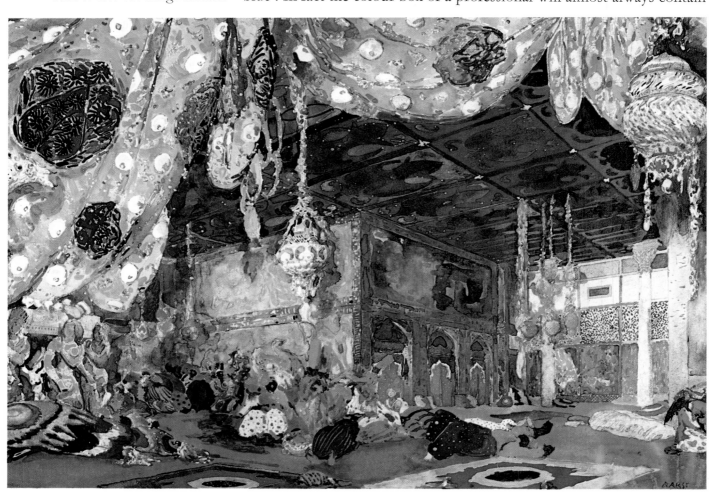

fewer colours than that of an amateur. This is because you can mix all the colours you need from a small number of basic colours. In theory you can mix all colours from the three *primary* colours, red, yellow and blue. However, in practice, you need more than that because impurities in the composition of the pigments occur in the manufacturing process and these affect the mixing of the colours. Manufacturing complexities also mean that it is almost impossible to obtain 'true' reds, blues or yellows. All of them will tend to have minute quantities of other colours in them which also affect the mixing. A practical solution is to include two varieties of each primary colour in your basic set. The following list of colours constitutes a good basic set which should fulfil most of your colour requirements:

Cadmium yellow	Alizarin crimson
Cadmium lemon	Ivory black
Winsor blue	Titanium white
Ultramarine blue	Mauve
Cadmium red	Winsor green

This list consists of two versions of each primary colour, white (which is a non-colour and can never be mixed), and black, purple and green (which, although they can in theory be mixed, in practice are affected by impurities in the manufactured colours).

Mixing colours

The best way to find out what your basic colours will produce is to experiment freely with them. Use a good opaque white paper as a ground. Vary the amount of water gradually with each colour. You will soon begin to find out quite a lot about the properties of your colours.

Pin your experiments on the wall where you can study them frequently and make notes on them to remind yourself which basic colours you have used in each case. The object of the exercise is to fix in your mind a mental impression of each colour as it comes out of the tube or off the pan, and of the ways in which the colours combine with each other to make new colours. This is especially important in watercolour where mistakes cannot be corrected by painting over. Make notes also on the length of time your colours take to dry. Notice how watercolours become lighter as they dry.

The basic rules of colour mixing will not be entirely unfamiliar to most people. As children we all learn that if you mix certain colours together you will get other colours. *Primary colours* are so called because they cannot be mixed from any other colour. They are red, yellow and blue. *Secondary colours* are colours mixed from any pair of primary colours. They are orange, green and purple. Variations on these secondary colours are obtained by mixing the primaries in different quantities so that you get, for example, greens ranging from a light yellowish

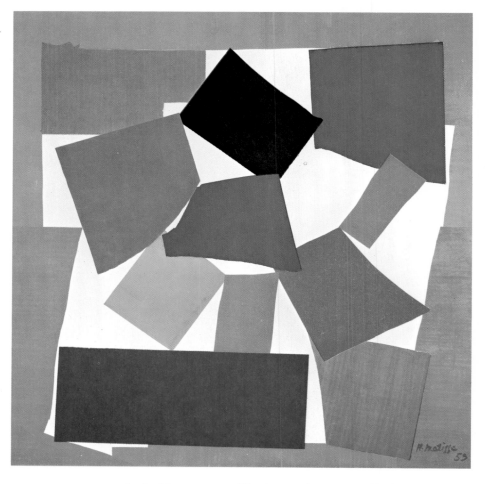

green to a very dark blue-green. *Tertiary colours* are all those colours other than primary or secondary colours, and are obtained by mixing three or more colours. If you mix all three primary colours together you will get a dark, neutral grey colour; in other words, the sum of all colours. In theory, this should be black but, in practice, impurities in the manufacturing process mean that it will be a muddy grey.

Complementary colours are those which when mixed together incline towards this grey because in some way they involve a mixture of the three primaries. For example, orange is mixed from red and yellow. Blue is the remaining primary colour so blue and orange are complementaries. Similarly, purple and yellow are complementaries, as are red and green. When mixed together, in effect they cancel each other out. When placed side by side, complementary colours tend to produce an impression of disharmony. In general terms, we say they 'clash'. This is because each intensifies the effect of the other. If large areas of complementary colours were used adjacent to each other the effect would, almost

certainly, be unpleasant. But if this contrast of opposites is cleverly manipulated the result can be enhancing rather than detracting. Imagine, for example, a field of bright green grass with a few brilliant red poppies scattered on it. The secret there is in the tiny specks of red against the large expanse of green. Each colour is intensified by the use of its complement. Experiment with complementary colours and explore the different effects which can be achieved.

The colour wheel

The relationships between colours are best demonstrated by the colour wheel. Make your own version of it in the following way and pin it up on the wall for reference. Draw a circle on a white ground. In the middle of it paint a patch of neutral grey obtained by mixing the three primary colours. Try it out on your palette until you have mixed a grey which does not lean in the direction of any of its components. Paint an area of each primary colour in a circle around this centre. Remember we have

Left: The completed colour wheel.

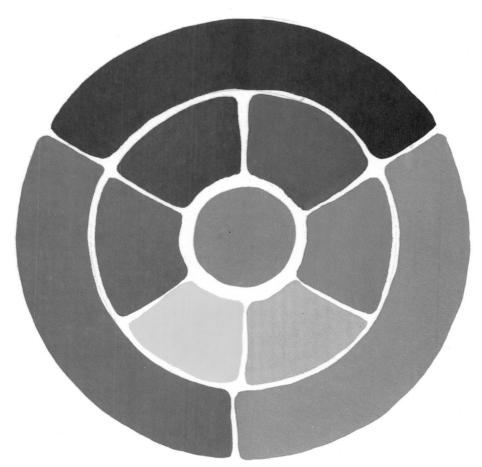

43

chosen two versions of each primary so the order should be as follows: Cadmium yellow, Cadmium lemon, Winsor blue, Ultramarine, Alizarin crimson, Cadmium red. Next paint the secondary colours in a circle surrounding the primary colours. Mix Cadmium yellow and Cadmium red to obtain a clear orange midway between yellow and red. Paint an area of this colour just beyond the areas of Cadmium red and Cadmium yellow in the inner circle. Mix Cadmium lemon and Winsor blue for a green and paint that just beyond the corresponding colours in the inner circle. Finally mix a purple from the Ultramarine and Alizarin crimson and complete the outer circle with an area of that beyond the colours of its components. From this you can see at a glance the relationship between primary and secondary colours. Look closer and you will also see that the colour on the outer circle which is opposite the primary on the inner circle is its complementary colour.

Below: In this exquisite watercolour by the German Expressionist artist Emil Nolde, he has used intense, brooding colours with a dramatic introduction of red into the sky. This is echoed in the shapes of the tiny houses. The work is called Friesland Farm under Red Clouds *and was painted c. 1930.*

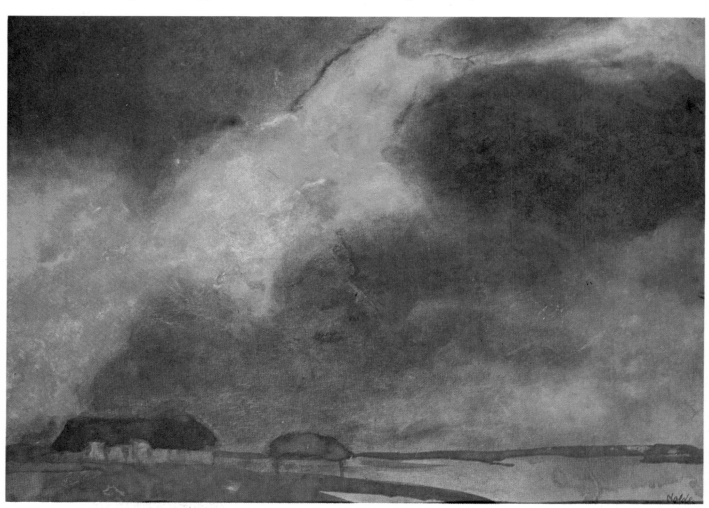

Colour changes

Colours are immensely volatile. They react to their surroundings almost as if they are living substances. We have already seen how complementary colours seem to react against each other, each one fighting for supremacy over the other. This absolute contrast intensifies each colour, sometimes to an unbearable extent. But all colours, to a greater or lesser degree, are influenced by those adjacent to them. This phenomenon is known as *induced colour*. Primary colours are relatively stable and are not markedly affected by other colours. Secondary colours are affected more than primaries but less so than tertiaries which are the most unstable. The appearance of tertiary colours can be profoundly affected by surrounding colour. There are various ways of demonstrating this effect. Try the following experiments. The colours must be as clear, clean and opaque as possible, so use gouache. Take several sheets of

Below: In this abstract called Gouache (1936) by Ben Nicholson, the colour red is again used as the central focus of the work which is composed of massed blocks of strong body colours.

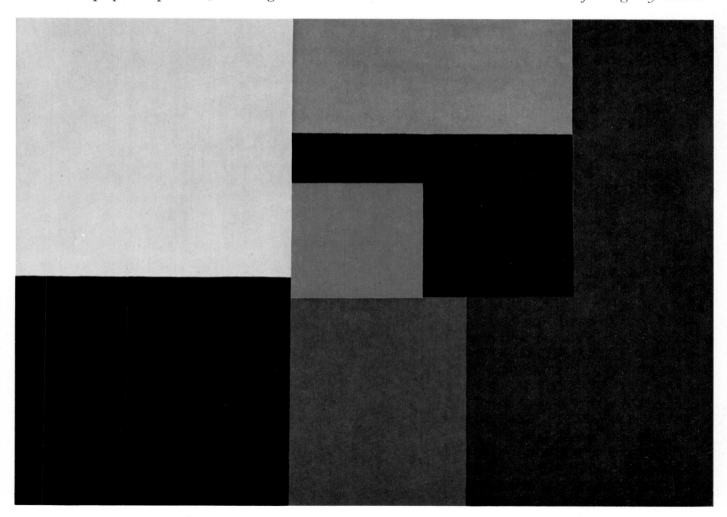

paper and paint each one a different colour. Then mix a tertiary colour, say blue-grey or pink, and paint another sheet of paper evenly in that colour. Cut the last sheet into small squares. Place one square in the centre of each of the other sheets. The effect of this on the appearance of the colour of the small squares will be quite dramatic.

Having mixed the paint you will know that the *actual* colour of the squares is identical. The apparent colour change is entirely a result of the influence of the surrounding colour. This effect is most marked with tertiaries but observable changes will even be found with primaries and secondaries. Try, for example, small squares of green paper against a background first of light yellow and then of deep blue. Against the yellow the green will seem dark and lean towards blue, against the blue it will seem lighter and more yellowish. Experiment a little further and

Figs. 1 and 2 are examples of induced colour using different areas of colour to describe the process.

you will find that this phenomenon is critically influenced by size or area. The larger the area of the square relative to the background the less it appears to undergo a colour change. In fig. 1, for example, where the square dominates the perimeter, the background has no obvious optical influence on the centre colour. Where the perimeter is dominant a colour change is induced even though the centre is a primary colour.

Distance and colour

To explore the influence of area further take a sheet of paper and paint on it two large areas of colour. Make the experiment more telling by choosing violently contrasting colours, say red and green. Next paint another sheet of paper with alternating narrow stripes in the same colours. Pin both sheets on the wall and stand back about 3m (10ft) to look at them. The first sheet will still show two distinct areas of colour. In the second, the stripes will appear to have merged into one over-all neutral shade. This tendency for small areas of colour to blend into each

other when viewed at a distance was exploited by Neo-Impressionist artists like Seurat and Signac. They developed a technique known as 'pointillism' in which the painting was built up out of thousands of tiny dots of different colours. In pointillist paintings the 'mixing' takes place in the eye of the beholder.

Local colours

Apart from the behaviour of colours in pigment form, the more you study the colours in the natural world the more you will discover that they, too, are influenced by factors other than actual pigmentation. These natural colours are known as *local colours*. The most immediately obvious effects on local colour are those produced by light and distance and both have been explored by artists for hundreds of years. If you try to match the colours in your painting exactly to those in nature you will soon realize that nature can be full of deceptive tricks. The colour of a barn roof one minute may change completely the next when the sky has clouded over. The effect of mist, for example, is almost to drain the

Below: In his painting Ajaccio (1935) *the Neo-Impressionist Paul Signac employs the difficult medium of watercolour to express the pointillist theory in which colour was applied in tiny dots. The basic technique is used here, but without the density of effect achieved in the oil medium.*

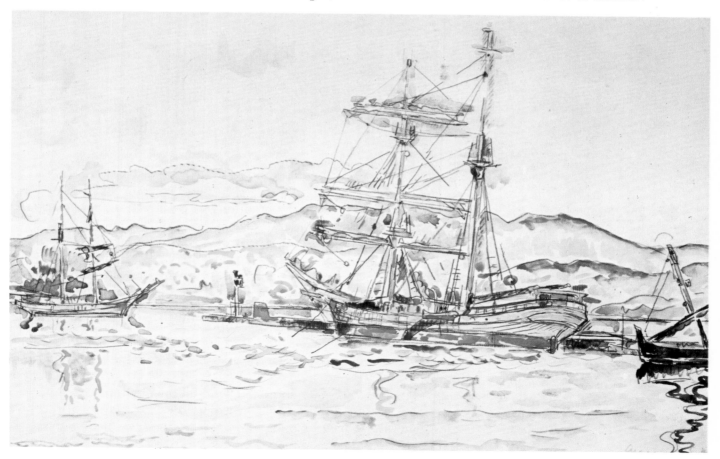

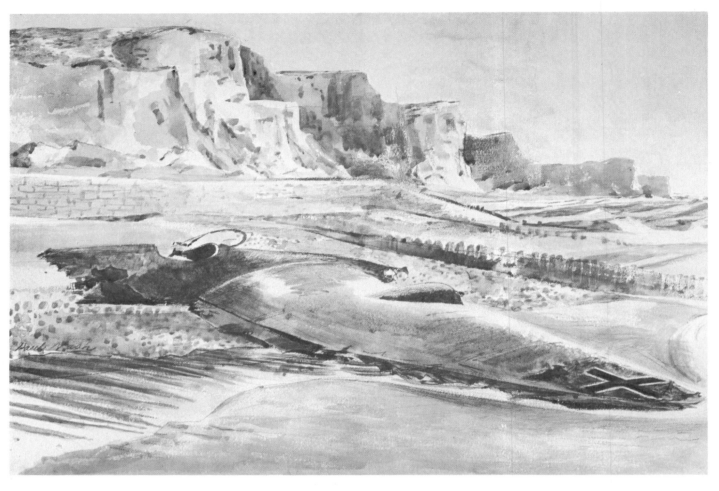

Above: The Raider on The Shore *c. 1945, by Paul Nash is one of the paintings commissioned by the British War Advisory Committee to contribute towards a visual/historical record of the Second World War. The metallic colour of the heavy grey machine in the foreground contrasts sharply with the delicate washes used to paint the cliffs as they recede into the distance.*

landscape of colour, to make it softer and more diffuse. Some surfaces appear to absorb colour, others—water, for example—reflect it.

Human flesh is amazingly receptive to light which is one of the reasons why portraits are so exciting and challenging to paint. An object which is part in and part out of shadow will exhibit marked differences in colouration. Distance also diffuses local colour. In a landscape, for example, the fields nearest you are strongly coloured. As they recede they become softer and dimmer, until in the far distance the hills on the horizon become almost blue or purplish-grey. Similarly in a town, look down a long straight street and observe how the colour gradually fades the further down your eye wanders. A knowledge of colour involves a great deal more than knowing how to mix your paints, although it involves that too. Careful observation is by far the best teacher. All the colour theory in the world is no substitute for the trained eye, sensitive to and appreciative of our natural surroundings.

Project: A Landscape

Once you have acquired your equipment and materials you will, no doubt, be anxious to get to work on a painting as soon as possible. The colour mixing exercises in the previous chapter will have given you some experience of the medium, but there are a number of basic techniques which you will do well to practise before you plunge into your first real painting. There are two major pitfalls for a beginner in any art or craft to overcome: the first is that you may be so overwhelmed by the technical complexities of what you are attempting that you are afraid to make a mark on the paper at all; the second is that you are so keen to get started that you want to run before you can walk and do not stop to learn the elementary tricks of the trade. The result in both cases is that many people become so disheartened that they give up altogether.

The solution to both these problems is to master the basic techniques

Below: A strong choice of a specific element in the landscape (the rocks and geological structure) is expressed by the artist James Ward (1769–1859). The work is one of the very few watercolours that he painted and is called Chisseldon, near Marlborough.

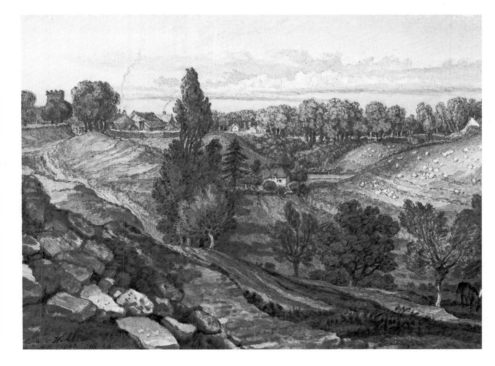

Above: Laying on a flat background wash with a piece of natural sponge. Notice that the paper has been left gummed to the board after stretching.

before you start, but leave the complexities till later. In the past many student artists were thoroughly trained in the technical aspects of their materials through the studio apprenticeship system. Nowadays there is a tendency to imagine that technique is unimportant and that 'self-expression' is the only thing an artist should be concerned with. In fact, the two are interdependent. Until you have a certain amount of technique you cannot express yourself, just as a small child cannot explain exactly what he means until he has acquired at least the rudiments of speech. This chapter will describe the rudiments of the art of watercolour painting. The more advanced skills of the art are discussed in the Techniques chapter.

Glazing

Traditionally transparent watercolour has been used as a series of thin layers of colour sometimes overlaid one upon another several times. This is known as glazing and is the core of watercolour technique. First find out the strengths of each of your colours. Use good quality white paper for the ground and pin the results of your experiments on the wall for reference. Taking each colour in turn, load the brush and paint a rough rectangle, establishing a fade of colour from maximum density to a thin film with one load of colour. You will find that some colours have considerably more covering power or strength than others; some change colour as they dry. When this exercise has been completed for each colour it will serve as a simple performance chart which you should keep constantly before you as a reminder of your practical discoveries.

Now try glazing. First explore the possibilities of the same colour laid over itself several times to achieve a rich density. Allow each layer to dry before applying the next. Then see what happens when one colour is glazed over another, for example, Viridian over Cadmium red produces a superb rich green. An influencing factor on glazing is the nature of the paper itself. Some are more absorbent than others. Experiment with different types of paper. The less absorbent the paper the more the colour sits on the surface and appears fresher as a consequence. The more absorbent papers tend to deaden the colour slightly. Another advantage of less absorbent papers is that washing out is easier.

Washes

Colour washes usually, but not always, form the basis of a watercolour painting. A wash is a film of diluted paint applied to the ground.

Flat wash

The flat wash or even-tone wash is the most basic kind of wash. The evenness of tone or colour must be maintained throughout the wash so first prepare sufficient colour to complete the job. If you have to stop

Above: Haresfoot Park, near Berkhampstead, Herts. (*1915*) *by Philip Wilson Street is a typical example of the use of fast, impressionistic washes in building up the picture.*

and mix more it is likely to be of a slightly different density and even minute differences can lead to an ugly overlap of colour. Use a large mop brush. Some artists like to keep the board flat when applying washes; others tilt the board slightly toward them allowing the paint to collect at the bottom of each stroke. This is then taken up in the next stroke. Whichever method you use, work swiftly and deliberately in horizontal brush strokes, from left to right if you are right-handed and right to left if you are left-handed. If you have made a mistake, start again. Do not touch the drying paint or try to correct uneven areas. Experiment on different pieces of paper with various colours and depths of colour until you can achieve a smooth even finish every time. If you like, try applying washes with a sponge. This must be a piece of natural sponge of the sort available from most art shops or pharmacists. Synthetic sponges do not hold the paint evenly and are not recommended.

Graded wash
Graded wash is a development of flat wash where a change in tone occurs gradually through the area covered. It is frequently used when the artist

wants to grade the sky from dark at the top to light at the horizon. It is applied in the same way as even-tone washes except that you begin at the top with the darkest pigment and add a little water to each brush stroke so that the colour lightens as you go down the paper. Or you can go from light to dark by adding pigment with each brush stroke. The most difficult part is to achieve a graded wash without noticeable breaks of colour which would give a striped effect.

Using background washes

Once you have practised flat and graded washes several times, using different colours and different brushes, you will begin to get a feel for the range of effects which can be achieved. With this confidence you can use the washes as the basis for a picture. Many watercolourists apply washes as the beginning of any picture, simply to give a softer colour as a base. A pale grey or sepia background immediately avoids the heavy contrasts implied by white. Virtually any subject has a predominant shading of, say, grey, blue or cream, from which the artist can begin his composition.

Below: The strong, bold brushwork used in John Marin's watercolour study called Deer Isle, Maine *(1937) demonstrates the artist's firm control over his technique.*

Washes are also used to apply the main colour areas on a picture. It is only when these have been applied that the artist will begin to fill in the details of a scene.

Brush strokes

It is important before you start painting to familiarize yourself with different brushes and the marks they can achieve. Some beginners make the mistake of using the same brush throughout a painting. Load each brush with sufficient paint and trail it across the paper gradually increasing the pressure as you go. As you lift the brush it should return to its natural shape. You will find the larger sables extremely versatile, being capable of creating both a clean line and a larger area of colour. The mop will be of little use beyond establishing large washes. The smallest sables (rounds) have fine points which allow real drawing control from fine lines through to thick, bold strokes.

Below: In complete contrast to the Marin painting (opposite) this meticulous watercolour, Ewer Street near Gravill Land (1846) *painted by Hosmer Shepherd uses the finest brush strokes to express the architectural lines of the houses.*

Drybrush

Drybrush is a useful technique which can convey detail and supply textural interest. The brush is not actually dry, of course, but neither is it loaded with colour. It should be just moist. Hold the brush at a low angle to the surface of the paper and lightly skim over it. The paint should just touch the ridges on the irregular surface. The rougher the paper the more effective the technique will be, allowing the undertone to show through.

Wet-in-wet

This is a simple exercise and fun to do. Wet the paper with a pale coloured wash and, before it dries, place another brushful of darker colour on it. The second colour will run and blur into the first leaving a hazy outline. Used discriminately this technique can be very effective. The secret lies in controlling the outcome. A heavy-handed use of wet-in-wet can only lead to a soggy mess of colours running all over the paper. Remember that the wetter the first wash the more the second will spread into it.

Washing out the colour

Watercolour is ideally a very spontaneous art. Paintings should be completed swiftly and not 'worked on' too much if this spontaneity is to be achieved. However, mistakes are sometimes made and one does not always want to jettison the results of one's time and effort and start again. Fortunately there is a certain amount of scope for correcting errors. Most colours once applied can be mopped off with a soft sponge. Mask the area to be washed out with masking tape or a chemical masking agent available at art supply stores. This protects surrounding areas which you do not want to disturb. Then mop the colour off with a brush or soft sponge. Make sure your materials, brush, sponge and water, are perfectly clean. Afterwards peel off the tape or masking and allow the area to dry. Do not expect to get back to a pure white paper as a degree of stain is inevitable.

Whiting out

There will always be times when an area gets out of control and washing out is impossible because of potential damage to the surface of the paper. If this happens the area can be painted out with an opaque white waterproof poster paint. It must be waterproof or the white will dissolve into the overlay of fresh colour and make it chalky. It is inadvisable to use this procedure over large areas, for no matter how careful the application of subsequent colour it will not match exactly the colour applied directly to the paper.

Choosing a subject

Having mastered the basic techniques of watercolour painting you can now begin your first real picture. The previous exercises will not have transformed you into a Turner or Blake or Samuel Palmer, but from now on you will learn more by direct practical experience than by theoretical exercises. First you must choose a subject. Landscape painting has been a favourite of watercolourists for hundreds of years and, in many ways, is an excellent choice for a beginner. It allows you to explore the new-found knowledge of colour and technique without

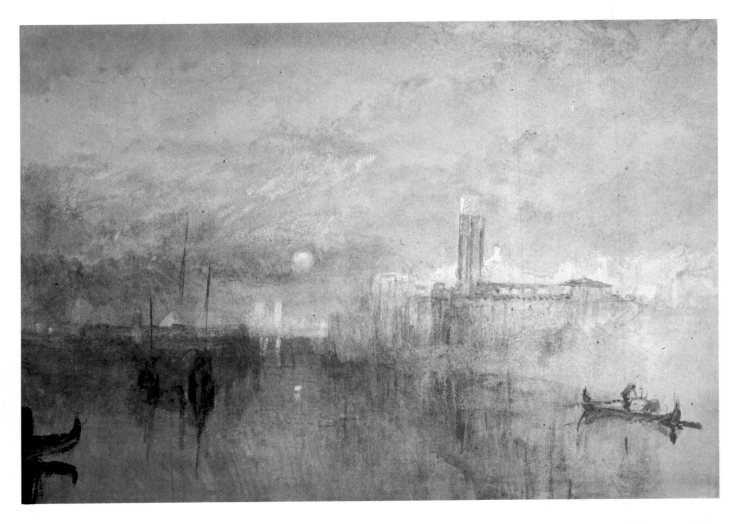

involving the awesome complexities of human anatomy which would be involved in figure painting or portraiture. Nor does your choice of landscape painting necessarily involve you in cumbersome expeditions into the countryside with all the problems of transporting equipment, of weather and the vagaries of nature. You can simply take your sketchbook and make several sketches of subjects which catch your eye and paint the picture at home with all your materials and equipment at hand. Alternatively, go into your garden or look through your window and paint what you see there.

What is a landscape?

When we think of landscape we imagine a vast panorama of fields, trees, mountains and sky with, perhaps, a river running through it. But, in fact, there are almost as many different kinds of landscapes as there are

landscape painters. Generally speaking, a landscape is a picture of something which is outdoors rather than indoors, and in which the focus of interest is on natural or man-made surroundings rather than on the human figure or figures. This does not mean, of course, that you cannot have figures in landscapes, only that they are not what the picture is primarily about.

Rural landscape

The rural landscape, in other words, the countryside, has always been particularly fascinating to landscape artists. Its continuing popularity owes much to Constable, Turner and the great watercolourists of the eighteenth century. Even in the twentieth century it is still a favourite subject with painters, perhaps because of the contrast it offers to city life and because it provides a link between them and the great painters of the past. It is still possible to go into the countryside and imagine that you are seeing it just as Turner or Constable did. The natural light still plays over the cornfields and through the trees exactly as it did when they were alive. The sea crashes against the cliffs in the same way and the sky can be as cloudless or stormy as ever it was.

Below: A fine example of a perfectly balanced rural landscape called Kirkstall Abbey *by Thomas Girtin. Notice the proportions of sky and land, also the use of the powerful sweep of the river to give movement to an otherwise static vista.*

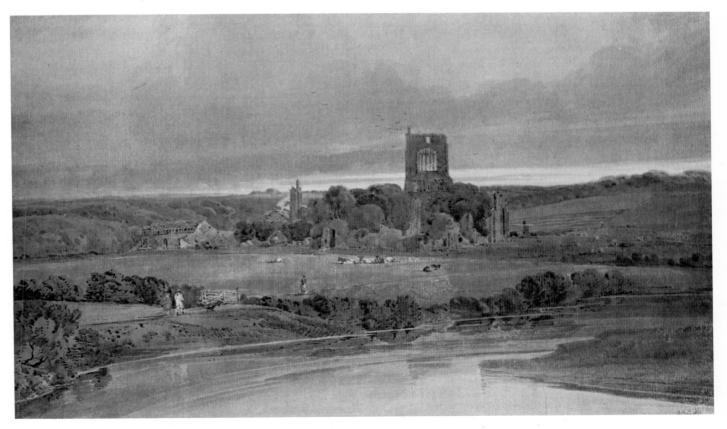

Urban landscape

If some painters are interested in the unchanging face of nature others are fascinated more by the effect of man on his surroundings. The urban landscape has proved of particular interest to a growing number of artists in the twentieth century, possibly because the changes have been so devastating and dramatic. The poetic beauty of the urban landscape seen through fog, in sunlight, at night, in rain or snow are well-established traditional themes. Nowadays, a more searching critical approach has developed, inspired in part by German artists like Max Beckmann, Otto Dix and George Grosz who confronted the viewer with the brutality of the urban vista. Other artists seem to relish the very artificiality of urban existence and their paintings may celebrate a service station or advertisement in the same way that traditional landscape artists may have celebrated a cluster of trees or a peaceful lake. As you will realize, a landscape today can mean anything from a fiery sunset, a pattern of clouds wafting across the sky or a ship on a storm-tossed sea to the latest automobile. The quality of your picture will depend on whether you succeed in conveying what you see.

Below: The stridency of urban life is brilliantly exposed in The Millionaires, *by the German Expressionist painter George Grosz. He used his art to satirize the horrifying contrast between rich and poor in the Germany of the inter-war period.*

Establishing the view

Whatever subject you choose your initial difficulties will almost certainly be practical ones. The first is which part of the subject in front of you should you paint? You will undoubtedly be seeing more than you can transfer to your paper. If you are working from sketches you will already have selected your 'frame' i.e. the area that you are working within on paper. Perhaps, the window frame in your room can serve the same purpose. Otherwise cut out a number of viewfinders. These are cardboard frames with windows of different proportions cut in their centres. The window should be no larger than 10cm to 15cm (4in to 6in) square, and the surrounding frame roughly 2.5cm (1in) deep all around. The cardboard used for cereal boxes is ideal for the purpose. Measure the square to whatever size is required. The frame will provide a rigid viewer that can easily be held up without bending. The proportions of the opening should be related to that of the paper on which you intend to work. If it is square the opening should be square; if it is rectangular the opening should be rectangular.

Using the viewer

Now try the various viewers holding them up before your vista at half arm's length from your eye, moving them up, down or across until an interestingly balanced arrangement can be found. Make a mental note of the important points that are to be incorporated and quickly attach an armature of some kind to the back of your board or easel support and pin the viewer to it. It is important that you try to keep the position of your head constant as the slightest movement in relation to the viewfinder alters what can be seen through it. Now begin to work a simple delicate pencil drawing (using a soft graphite pencil, say, 6 or 2B) to establish the main shapes and rhythms as accurately as possible. If things go wrong just rub out the drawing gently with a clean kneaded eraser and restart. Do not re-work too extensively. The delicate lines are purely a guide and as you lay on colour you may be obliged to rethink shapes and positions. An additional reason for not re-working the surface of the paper with a pencil is the very real risk of damaging it.

Focus

One of the problems when working a painting is caused by the ability of the eye to change its focus of interest continually. This can result in a badly composed picture with no real centre of interest because, as you work, you are giving that particular part all your attention. A way of combating this tendency is, having chosen a view, to write down what it is that makes it interesting and refer to that statement regularly during the act of painting. Examine the Edward Bawden painting of the Canmore Mountain Range. Although the vertical lines of the crosses and

Above: In his painting The Canmore Mountain Range (*gouache*) *Edward Bawden has used the shapes of the grave surrounds in the foreground and the skyline of the mountain range to powerful effect.*

grave surrounds dominate the foreground, they also lead the eye straight to the focal point, the mountains themselves. Having decided on your composition, quickly and lightly map in the major movements and shapes. Lay in the main areas of colour, then gradually develop the details of colour texture and shape based on what you see, not what you think you see. For example, a tree seen at 20m (22yds) is very different from the same tree seen at 100m (120yds); the colour will apparently change owing to atmospheric light as will the visual pattern of leaves.

Practical problems

In your haste to complete your first picture do not neglect to refer back to your exercises when you encounter difficulties. Colour mixing may be proving troublesome. If your greens are too blue try adding a little yellow. If your reds are too orange, mix in blues, greens or purples to try and combat this. Consistency may be the problem if the paint is used thickly with aquapasto. Use a palette knife for mixing and apply the paint with a palette knife or hogs' bristle brush. Remember, this will take longer to dry than the traditional application of thin transparent films of colour. Removing thick impastos of paint is harmful to the paper surface, so begin the painting with thin films of colour and only begin to build impastos when you are sure of what you are doing. Pure watercolour from pans is so liquid that it mixes easily, but always be parti-

cularly careful when using aquapasto with tube colour. Gouache and poster colour can also prove awkward particularly with a white base and care must be taken to avoid streaks. Remember also to load the brush well. Even the tough hogs' bristle can be damaged if you try to force pigment from it onto the paper.

Restrictive colour

Another issue that could prove troublesome is the amount of colour involved in the vista. Although bright, strongly coloured forms may seem attractive, it is very difficult for a beginner to cope with strong colours. It is probably wise to begin with a fairly restricted colour range consisting mainly of the whole range of umbers, greys, greens and blues. This restriction is only a suggestion and does not have to be closely adhered to, but it may prove useful and will certainly help to make your progress to total visual harmony easier. These colours may seem simple or dull but they can provide exciting visual and technical problems.

Format

The choice of format is another factor which is often overlooked by beginners. In fact, the format of a painting can have a serious effect on its subject matter. Landscapes have traditionally been painted in a horizontal format but this is by no means a rigid rule. Consider the landscapes illustrated in this chapter. The Georgia O'Keeffe painting has a vertical format designed to encompass the dramatic oval shape in the foreground which is really the main point of interest. The horizontal format of the Girtin reinforces the sweep of the landscape. In the Ward painting the format remains horizontal but the apparent high vantage point allows the entire surface to be occupied by landscape, the sky being unimportant. It is worthwhile experimenting with different formats. You will find that some subjects work infinitely better in certain formats than in others. In fact it can make all the difference.

A sample project

By the time you have completed your first picture you will have encountered several of these problems and possibly more. Maybe you are not too happy with the result. Do not be disheartened. The more you paint the more you will learn. Be persistent and you will improve. Sometimes it is helpful to see exactly how someone else has built up a painting from the beginning. This is often very difficult to judge from a finished picture particularly if it is a complex one. The following step-by-step exercise has been devised to enable you to see at a glance the processes which went into painting one particular picture. This sample project was painted by Peter Morter.

A Landscape step-by-step

After the drawing is roughly sketched in, mix a medium tone wash of Winsor blue. Because this colour on its own gives a somewhat raw effect, mix together a touch of Vermilion and pale Cadmium yellow with more blue. Add this mixture gradually to the blue wash to make a slightly greyer shade.

Dampen the area which is not to have the blue wash with a large brush and clean water. It should only be slightly damp. Then apply the wash with your largest brush over the sky area. Allow the paint to be very wet and then rinse your brush in clean water and use it on the wet paint to create cloud effects. While the paint is still wet you can also work in more blue paint to create a stormier sky. You must be careful not to overwork the area or it will become sodden and any subtlety of effect will be lost. Keep blotting paper handy to mop up any excess moisture around the picture.

When the blue wash is thoroughly dry, the green is applied. To create a good basic green, mix approximately equal amounts of blue and yellow. Apply the wash lightly and allow it almost to dry. Add more blue to the base to deepen the green and, using a chisel-edged brush on the flat side, boldly paint in the tree shapes and the curves of the grass.

The paper has a textured surface so, using the drybrush technique, lightly drag the brush over the surface to create a texture in the paint. Remember the brush should be only just moist with paint. Do not work in a constant colour but add small quantities of blue or red to deepen the tone.

The development of shapes within the picture is achieved by using a combination of the chisel-edged brush and a large brush loaded with clean water. To work in the darker areas, the colour is etched in, and then the brush is used with water working in from the outside of the colour area to create soft flowing edges.

Use the edge of the chisel brush to put in any fine detail required, although in this type of picture it is important to keep the effect loose and free. A small amount of detail will add interest and depth to the

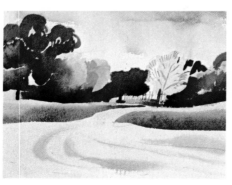

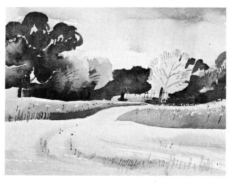

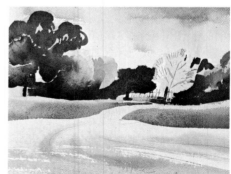

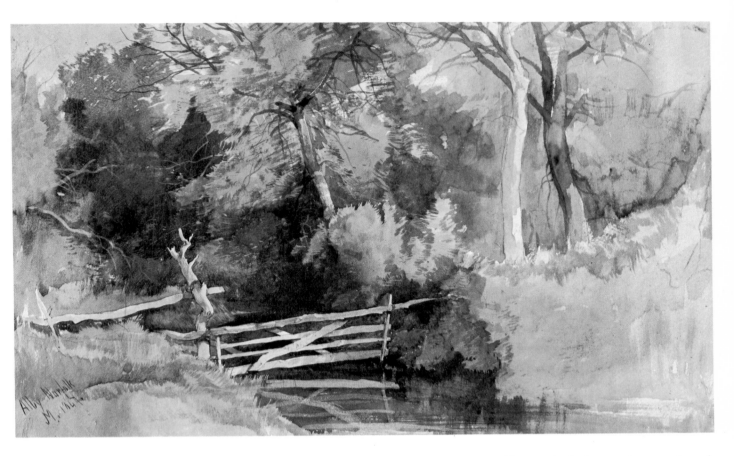

finished painting. Here a few dots of red were added to look like poppies and the point of a sharp knife was also used to scrape the surface of the paper lightly to create highlights.

Equipment for outdoor painting

As soon as you have gained some experience of painting your immediate surroundings, it will be time to venture further afield into the great outdoors in search of new subjects and sources of inspiration. It is advisable to choose a place with which you are relatively familiar to begin. Ideally this should be a fairly sheltered position away from the distractions of curious onlookers, high winds or straying cattle or sheep. Prepare your papers before you leave home. It is as well to keep the picture size small in outdoor situations, so prepare several small pieces rather than one big one. Remember that the light changes constantly in the open air and the secret is to work very quickly and spontaneously. It is also important to make sure that before you leave home you have everything which you are likely to need. There is nothing more infuriating than arriving at your destination only to find you have left some

Above: An intimate close-up view of the landscape is also possible, as shown in this delicate watercolour by John Middleton (1827–1856). The work is called Alby, Norfolk.

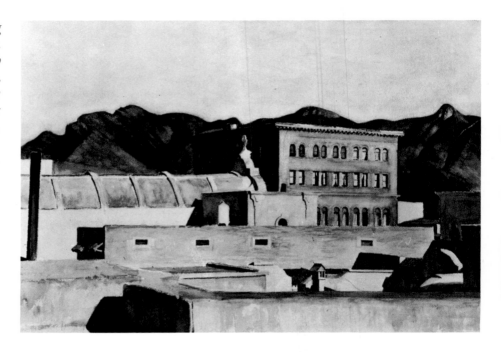

vital piece of equipment at home. Compile a checklist of items and consult it before you leave. The following list should supply most of your needs:

A sketching easel and seat
A variety of brushes
Paints
Palettes
A sketch pad
A palette knife
A sharp-edged knife
Several sheets of prepared paper
A supply of pencils and a blade or sharpener
A kneaded eraser
Rag for wiping surplus moisture off brushes and palettes
Blotting paper
Masking tape for masking out areas to be washed out
A natural sponge
Screw top water containers (preferably plastic) and a supply of clean water as you may not have access to any close by
A drawing board and clips to hold the paper.

Most of this can be transported in a large rucksack or carry-all. The board and paper, however, will require a large waterproof container. A simple ground sheet sewn up into an envelope slightly larger than the board is an ideal solution and makes for relatively easy movement.

Elements of Composition

By the time you have completed a few landscape studies you will be gaining in confidence as far as handling the materials is concerned. The composition of the picture has until now been a purely intuitive process. Perhaps you did not even realize that you were, in fact, composing your paintings. Surely in the case of landscapes, nature is doing the composing for you? Certainly the scenes you painted were not of your making. Nevertheless, the very act of choosing a particular vista from a particular vantage point is, in itself, an act of composition. Out of the millions of possibilities available to you, you selected a particular cluster of trees, buildings or pastures because in some way it appealed to you. The cardboard viewfinder helped you to find exactly the right viewpoint to

Below: The composition of a work is crucial to its success. In his painting Region of Brooklyn Bridge Fantasy, *John Marin maintains fine control over a wide range of elements in his urban landscape.*

emphasize the essential qualities of the subject matter. In making these choices you were composing the picture. It is now time to look at this question of composition more closely since it is an essential element in the making of a good picture in any medium.

What is composition?

Composition simply means the arrangement of the parts of a picture so that they add up to a harmonious whole. A well-composed picture will have a balance of forms, coloration and tonal values. It will have proportion, space, rhythm and a unity of subject matter so that the eye

Right: A classic compositional device is used by Tintoretto in The Saving of the Body of St. Mark *painted between 1562–1566. Notice the deliberate use of perspective lines to emphasize the depth of the background.*

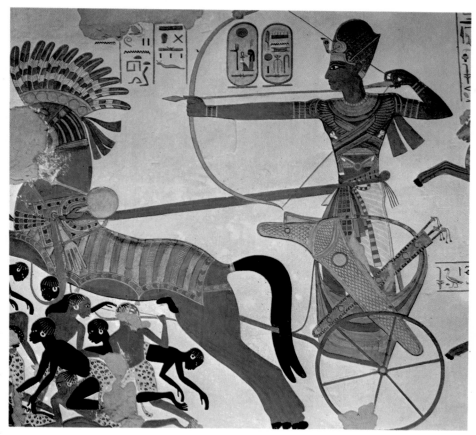

Left: Egyptian art had its own formal rules of composition, based on symbolic significance which frequently ignored the rules of perspective. For example, this wall painting of Ramses II (1290–1223 B.C.) represents the king twice as large as the fleeing figures. Below: Some artists deliberately distort realistic shapes to define their composition and to create a new dimension. Paul Klee, one of the most inventive painters of the twentieth century achieves a fantastic effect in his work Garden at Night.

travels around the picture in an orderly fashion rather than leaping from one part to another in a disjointed way. There will be a hierarchy of centres of interest so that no two points battle for attention with each other. Since painting is an art not a science there is no one foolproof way to compose a picture. It is something that you will learn by experience of your own work and by looking at the great masterpieces of the past and analyzing their achievements. The rest of this chapter will be devoted to some of the main elements of composition which you should bear in mind.

Perspective

An understanding of perspective is essential for anyone who wishes to paint naturalistically. Perspective is basically a device which enables the artist to create an illusion of three-dimensional space on a two-dimensional surface. All objects have three dimensions, height, width and depth. A sheet of paper has only two—height and width. The creation of an illusion of depth is not something which is common to the art of all peoples and all ages. Ancient Egyptian art, for example, took no account

Fig. 1 *The basic principles of central perspective are demonstrated in this diagram.*

Fig. 2 *First stage in demonstrating the circle in perspective.*

Fig. 3 *The optical size of two identical semi-circles in space seems to have changed.*

of perspective. Nor do the drawings of young children or those of most primitive peoples. In many cases, for example, in some Indian paintings perspective is distorted to an extraordinary degree so that there is no relationship at all between the sizes of people, animals and buildings in the paintings and their actual proportions in real life. Sometimes the most important figure, for example, the prince or ruler, was painted larger than less important figures. This is not because they were bad artists but because they were not interested in perspective. The great advances in the study of perspective in the West took place during the Renaissance, when many artists seemed to have been virtually obsessed with the idea. Most of our understanding of perspective today derives from them.

Central perspective

The most commonly used system today is that known as 'central perspective'. In simple terms it states that all parallel lines disappear at a point on the horizon called the vanishing point. The horizontal lines remain horizontal. The following exercise will help you to understand the basic principles of central perspective. Take a sheet of paper and draw a horizontal line about a third of the way down to represent the horizon (see fig. 1). Somewhere near the centre of this line mark the vanishing point. Draw another horizontal line about a third of the way from the bottom of the sheet and mark its central point A.

On either side of point A mark off a number of points spaced equally apart and draw lines connecting each of these points with the vanishing point. Just beyond the second horizontal line draw another line parallel to it. This will cut off areas that optically suggest squares drawn in perspective. From point A draw two lines along the diagonals of the two centre squares and project them to the horizon to points Z and X. Where the lines AZ and AX intersect the lines drawn through the vanishing point, draw a series of horizontal lines parallel to the others. This will establish an optically diminishing spatial plane. Notice how the horizontal lines get closer and closer together as they recede towards the horizon.

Remember all parallel lines within this theory meet at a vanishing point. This system will help you to recognize why certain points are optically smaller than others. Spatial illusions rely on this system or similar ones. The purpose of the exercise is to help you recognize shapes and angles and measure distance. Remember also that all verticals remain vertical, unless a very acute angle of view is presented.

The circle

The circle seen in perspective presents a particular problem. The ellipse, as it is called, is a simple form to construct if you remember certain points. Bearing in mind the central perspective system draw a square on a sheet of paper and quarter it (see fig. 2). Then draw a circle within the square. By rotating the sheet around the pivot AB you will begin to see the circle take on an elliptical form. Look along the axis lines CD which will remain vertical, though visually foreshortened. The flanking lines YZ and TS will seem to converge towards a point situated directly beyond the point D, the projected vanishing point. Look at what seems to happen to the two identical semi-circles in space. The semi-circle ADB becomes optically smaller than ACB because it appears to have moved towards YT from ZS. In other words the centre of the circle X moves closer to D than C (see fig. 3).

When drawing a tall cylinder, a chimney pot, for example, you must establish your eye level very clearly bearing in mind the points on the ellipse. The top of the chimney is above your eye level so you construct a quartered square in perspective with imaginary projection lines (see fig. 4). Bear in mind the acute angle of vision that might be presented when looking up at tall forms. Most chimneys have a natural taper built into their construction but some are simple cylinders held in position by guy wires. Remember what appears to happen to two parallel lines in a drawing. When you are constructing an ellipse the diagram structure can be useful, although with a little practice it can soon be dispensed with. Always take the ellipse just beyond the vertical. This is a trick but it does suggest structure beyond the field of vision.

Fig. 4 When viewing a cylinder, construct a quartered square in perspective in the imaginary projection lines.

Fig. 5 The perspective of a circle when viewed from a different angle.

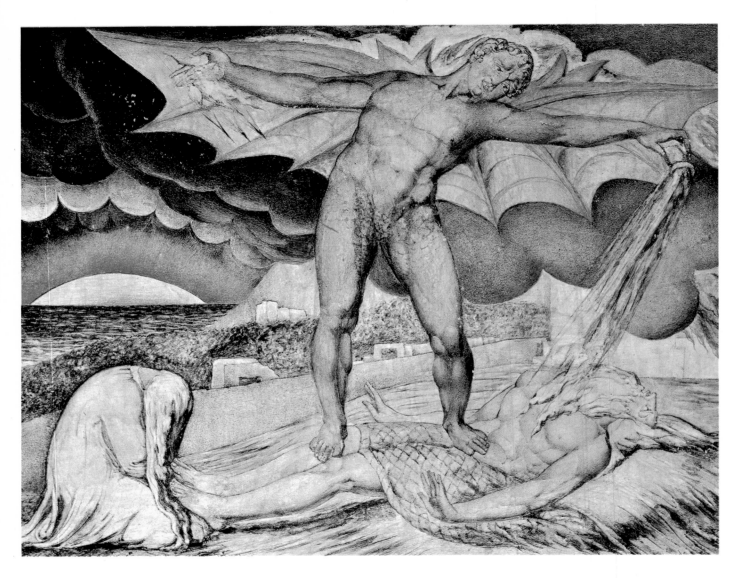

Fig. 6 The use of spatial areas is crucial to the success of the painting. In figure composition the foreground usually contains the major focal point, as in this painting by William Blake called Satan Smiting Job with Sore Boils.

These constructions deal with a perfect geometry. But not everything seen is immediately at right angles to your field of vision (see fig. 5). The centre X of the circle seems to be closer to CD than AB and also to CA rather than DB. In this particular diagram the four sections of the circle are each of a different size.

Scale

Scale must be established at the outset of any painting. A large vertical form, perhaps a gatepost, pole or tree will be useful here. The length of this mark is the key for all future marks. Refer back to it as each fresh statement is made. An inaccurate decision may make it impossible to

carry out your original intention, the scale chosen being either too great or too small. Do not hesitate to restate the scale if necessary. The nature of watercolour technique will allow this restatement early on as you build one transparent layer on another, working through from pale to dark. But always refer back to the original decision, or shapes and lines will lose their relative scale. A simple framework of shapes must be established to indicate an illusion of space through linear direction and

Fig. 7 Eric Holt's painting titled Smallholdings *demonstrates the use of circular composition, which leads the eye irresistably around the work.*

Fig. 8 (right) A brilliant use of space and proportion is shown in Edward Burra's work Forth Road Bridge. *The overhead viewpoint emphasizes the architectural lines of the bridge over the landscape, and its dimensions are further enhanced by the tiny scale of the traffic crossing it.*

scale change. This spatial illusion will be reinforced by an analysis of the way colour operates in space. A highly detailed foreground can also emphasize the impression of space.

Space

Every painting has three basic spatial areas: foreground, middleground and background. With figure composition the foreground usually contains the focal point of the painting. An example of this can be seen in *Satan Smiting Job with Sore Boils* by William Blake (fig. 6). All additional elements become stage props in support of the main intention. But this is not a sacred rule. The centre of interest of a painting can be much less obviously placed. For example, Eric Hart's egg tempera painting *Smallholdings* (fig.7) is a carefully organized complex composition allowing the viewer to be led in and around the whole diary of events before arresting on the focal point. Some painters are brilliant at creating unexpected moments, using foreground figures in soft focus, partially cut off by the edge of the canvas, or taking exceptionally high vantage points to capture unexpected moments of movement and colour. In Burra's *Forth Road Bridge* (fig.8) the dramatic intrusion of the giant bridge into a dark landscape is emphasized by the almost ant-like scale of the traffic.

Below: A grid helps to establish the different areas of a painting. Here a window has been used as a natural grid in this landscape by a twelve year old child.

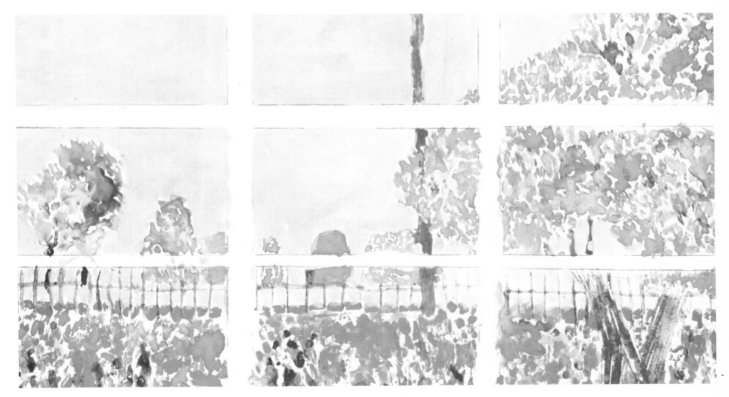

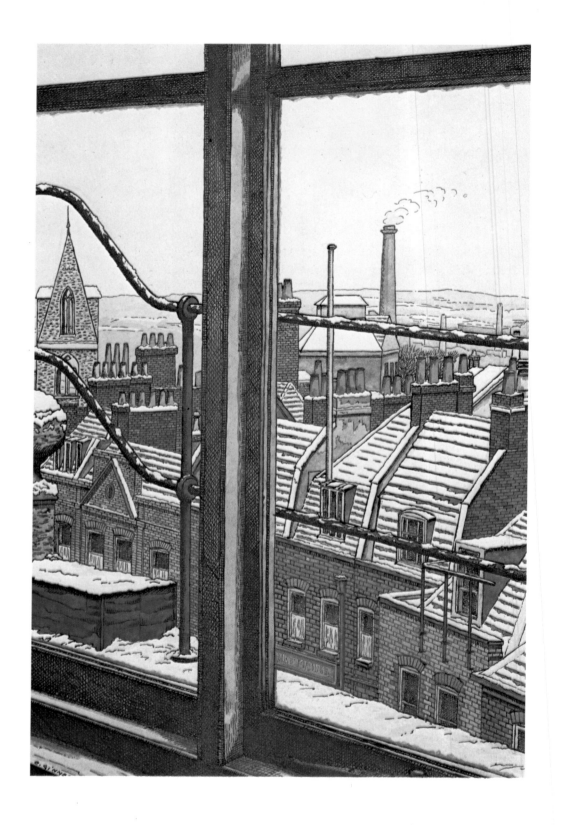

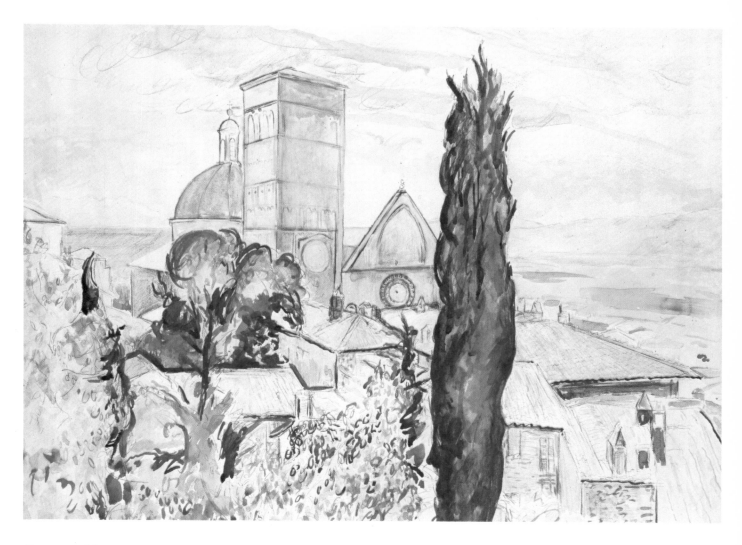

Centre of interest

The centre of interest need not be a physically large element in a painting but it must be a point that provides a natural axis for the composition. It may be an object or a person or even an area of unexpected colour in an otherwise sombre vista. Needless to say it is almost never located in the geometric centre of the picture and all other elements in the picture must be subordinate to it.

Urban landscapes

In theory urban landscapes should present no more difficulties than rural ones. In practice, the complex web of shapes, details and directions can be daunting for the beginner. It can help to reduce the confusion of this complexity if you first establish a grid on the paper of the major divisions

Above: Urban landscape can be both serene and beautiful as shown in this painting by Edward Wolfe, Assisi from Lady Berkeley's Garden *(c. 1960).*

Opposite: The view from a window can provide an exciting study in urban landscape, as demonstrated here in From a Hampstead Window *(1923). The painting is by Charles Ginner, and is done in a combination of pen, ink and watercolour.*

75

that occur within the chosen vista. Take a large sheet of glass, or if you are working from indoors use a window, and paint on a 5cm (2in) grid in thin white paint (emulsion paint is ideal: it dries quickly and can easily be removed with methylated spirits). Place yourself comfortably before the window or the sheet of glass mounted on an easel. If you are using glass, tape the edges. This prevents accidents and acts as a useful frame.

Using the grid

Make sure your eye level is approximately at the centre of the grid. Take a small sable brush and some thin gouache paint, preferably in a bright colour, and trace around the major shapes that you see before you. This exercise will make you very conscious of scale change through distance and foreshortening. You will also notice that with the slightest movement your trace lines will move out of alignment with the view behind. So always position yourself as accurately as possible to avoid this.

Establish the horizon. In a cityscape you may choose to make this the main feature of your painting. The rich ever-changing shapes of church spires, roof tops, chimneys or the view of your next door neighbour's neat herbaceous borders against the rich formal patterning of a brick wall may prove a rewarding choice of subject. In the latter case, you may choose to eliminate sky and concentrate on the flowerbeds or the garden tools leaning against the wall of the shed. Refer back to the original tracing and try to establish the basic linear shapes on the paper in lightly drawn pencil. Then begin laying in major areas of colour. Consider the shapes of objects at all times. Always build from big shapes to small. Involvement in detail will, however interesting, lead to isolated images and a complete breakdown in the fundamental relationships of the vista.

You must always look at the particular shapes carefully, seeing them in relation to the other elements of the composition. The mapping out stage tends always to be mechanical. It is only as colour and tone are applied that a greater subtlety and depth arises. Do not be sidetracked by complex architectural details until you have established the main elements.

If you are unhappy with your first efforts do not necessarily jettison the subject matter. It is unlikely to be that which was at fault. In fact, it is a useful exercise for a beginner to experiment with different approaches to the same view, each one emphasizing a different element in the picture. One could be concerned with patterns and textural aspects, another with light and shade, another could accentuate foreground detail. One vista can supply any number of different paintings. Trying to analyze such possibilities is excellent training for the artist's eye.

Improving Observation

Choosing a subject

Although landscape has always been regarded as the ideal subject for watercolours, there is no need for this to be regarded as a restriction for the beginner. In fact, you can paint anything you like. This chapter not only gives some extra hints on how to observe and capture specific elements in the landscape, but also looks at other traditional areas of painting, including portraiture, figure painting and still life. Many people—and this includes professional painters as well as beginners—experience great difficulty in deciding *what* to paint. Perhaps the ability

Below: Gordon Crosby's choice of pictorial subject dominated his artistic output. He was fascinated with cars, which he painted with great delicacy. Here he captures a dramatic moment, a car crash on the Le Mans racing track.

Above: Naive or primitive painting has a direct, literal charm of its own. Timber Hauling by the White Horse (*detail*) *by H. C. Baitup.*

to perceive a subject immediately with the eye, and therefore 'frame' a complete painting is inborn in some fortunate individuals. This sense of knowing what you want to paint becomes increasingly important to your development, since what and how you see is even more unique to you than your technical skills, and is the central feature of your own vision of the world.

Sources of inspiration
If you are not able to 'spot' your subject matter instinctively in the world about you, there are many ways of finding inspiration. Ideas for still life subjects are discussed later; however, you may want to explore other areas, such as the realms of your imagination. This will be particularly attractive to you if you have a good visual memory for images. Some people have extraordinarily strong memories of scenes and events from childhood, and it is fascinating how the original directness of the child's vision is expressed with the adult's power to recall it. The qualities of so-called 'primitive' or 'naive' painting express these combined visionary forces perfectly, and although this form of art is described as primitive, it is in fact very sophisticated. Naive painting is not always simply a matter of looking back to the childhood world—often people who take

up painting late in life (Grandma Moses for example) have never lost their childhood vision, and this totally suffuses their work.

Fantasy and surrealism

If you visit a gallery which has a good selection of modern art, you will probably see that one of the main features of painting in this century and the latter half of the nineteenth century is the high proportion of work

Left: In his painting Salome, *by Gustave Moreau (1826–1898) the artist has pursued his preoccupation with painting highly romanticized subjects, often taken from the Bible as the original source.*

which either uses fantasy and dream as its subject, or uses it to express a point of view. Whatever particular 'school' is represented, whether it be Expressionist, Dadaist, Surrealist etc. the different view of reality which is communicated is vitally important, and divides modern art from the more representational work of previous centuries. In one sense, this is not entirely new—Blake comes to mind immediately, also Bosch and Bruegel. However they were rare in their vision, while nowadays we take for granted that, in the most general sense of the word, 'surrealist' art is a natural part of our way of looking at life. Most of us have fantasies, though we often are not very conscious of them, and people vary in their capacity to visualize their inner world. Sometimes, just seeing other work of this type can stir up your own world of fantasy images. The ability to pay attention to what goes on in your head while you are going about your daily routine can be deliberately developed. Instead of letting an image go, notice it, follow its growth, and as soon as you have an image, draw it.

Dreams

Some people say that they never dream. Others that they have dreams every night, and experience incredibly powerful and vivid scenes while they are asleep. You may even dream in colour, although some say that this is impossible. The meaning of dreams is a fascinating subject in itself, but at this point we are looking at the images from the point of view of the painter, and how you can use them as subject matter. The problem with dreams is that they are so fleeting (although you may have a constantly recurring dream which is riveted on your mind). Generally, your dream will have disappeared from your consciousness very soon after you have woken up. People who make a habit of keeping a record of their dreams to interpret their meaning often keep a notebook at their bedside, and as soon as they wake up, write down what happened. You could borrow this idea, and keep a dream sketchbook. On waking, make visual notes of central images, and major shapes, and jot down details of colour and areas of light and shadow. Even this form of recording will only be of temporary use, and you should attempt to start your painting at once.

Above: Sketch of an Idea for Crazy Jane *by Richard Dadd, painted in 1855. Dadd was always finely balanced on the edge of madness, and his work inhabits a highly idiosyncratic realm.*
Opposite: One of Dadd's talents was for entering the miniature world of fairyland. This study is called Songe de la Fantasie

Making sketch notes

There is nothing more frustrating than seeing a particularly appealing subject for a painting, and finding that you have no way of capturing the main elements. The only way to avoid this is to always keep a sketch pad with you, even if you are just making a short journey, or going to the office. Some sketchbooks can be reserved for special subjects, such as nature studies, which will be discussed later. You'll find that you can use an all-purpose sketchbook in all sorts of ways, including making

Right: Animals are fascinting to sketch and paint. This charming study called Sketch of a Seated Cat *by Gwen John is done in pencil and watercolour.*

quick notes of events at home, involving pets, children, odd vistas of furniture and fabrics in different lights, in fact a multitude of ideas. Try to get as much significant detail down as possible. As with your dreams, there is always one particular quality that has made you pay attention—perhaps your cat's pose of total relaxation, or the concentration on a child's face while reading, or examining an object. As long as you have captured this central feature, the rest can be 'filled in' later. If you are

outdoors, and concentrating on a major element in a larger context, you might choose to take a photograph to supplement your sketch. Orthodox hands may be raised in horror at this suggestion, but many people find this extremely helpful, and as long as you are not planning to copy the photograph, and only use it for reference, then the camera is a perfectly legitimate supplement to your note-taking.

Other sources of inspiration

Sometimes other art forms can inspire your visual creativity—music can either act as a general source of stimulation while you are working, or act as a catalyst in its own right for all kinds of moods and images. On the other hand, some painters find that they can only work in complete silence, and music would confuse and distract them, rather than help them work. The imagery of poetry might evoke pictures—think of T. S. Eliot's *The Waste Land* for example, or an evocative classic such as Dante's *Inferno,* which provided Blake with so much of his inspiration. A modern painter might look at the enigmatic work of Samuel Beckett,

Below: Microscopic pictures of minerals reveal fascinating and beautiful structures which can be wonderful inspiration for a painting.

or children's stories, folk tales and nursery rhymes. Look also for pattern and detail—watch the sand at low tide, and the patterns made by the water. Examine rocks and crystals, try to get some microscope pictures: you'll discover an entire world with beautiful symmetry and structure, which will help to develop your own sense of form and composition.

Skyscapes

The importance of the sky to the landscape painter is self-evident. Within most landscapes it is the dominant feature, determining the mood or atmosphere of the whole. Painting a series of skyscapes *per se* will help you to develop your understanding of the changing nature of

Right: Cloud formations are a major feature of skyscapes. Here towering clouds build up over the sea, heralding the approach of a thunderstorm and providing a strong dramatic subject.

skies and cloud formations under different light and climatic conditions. By isolating this one, very important, feature of landscape you will sharpen your ability to observe its subtle variations in colour and mood. Use small sheets of paper so as to be able to make complete statements quickly. The deep luminous colour of the sky is one of the most difficult problems the artist may face. But, in many ways, transparent watercolour is the ideal medium for painting sky because it too has a luminosity which comes from the light reflecting from the white paper surface through the thin layers of paint. This transparency should be maintained in all your skyscape experiments. Thick, heavy layers of pigment should be avoided.

Even on a bright sunny day, when the sky appears to be a clear

Left: Cumulus clouds are challenging formations to paint, with their combination of fluffy, light textures and the hard, bright quality of their outlines against the sky.

uniform blue, closer observation will show that there are nevertheless considerable colour variations from, perhaps, deep bright blue at the zenith, moving down through paler tones to a pale yellow grey at the horizon. The appearance of clouds can be dramatic and, depending on their nature, they can totally alter the predominant mood of a painting. The colour, structure, shape and position of cloud formations must be closely studied. You cannot hope to copy all the details of shifting cloud masses or their infinite colour variations, but an understanding of the characteristics of each type will help you translate what you see in terms of the watercolour medium. Cumulus clouds, for example, are those large, white fluffy masses commonly seen against the vivid blue of a summer sky. They seem to be thick and almost tangible, billowing out

Left: A typical mackerel sky, composed of cirro-cumulus clouds. (The word cirrus is Latin for a curl of hair).

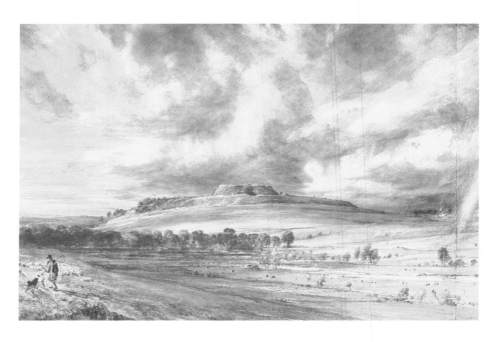

on one side and tapering on the other depending on the direction of the wind. The lightest, brightest white is at the top curvaceous edge of the cloud. The bottom edges are flatter and darker. Notice, also, the way certain clouds cast definite shadows on the ground beneath. Some windswept cloud formations seem to have almost no bulk or form at all, with almost no definition between them and the rest of the sky into which they merge. Rather than paint on areas of white, in such cases, you may prefer to lift off colour while the basic sky wash is still wet (see Techniques).

Similarly, rather than using heavy line to represent high, spare streaky cloud formations, use drybrush techniques (see the Project chapter) to give a light airy effect. Handle dark areas carefully. A storm cloud may seem to present an almost black-and-white contrast to an area of bright sky. In reality this is unlikely because forms in the foreground will probably be much darker than those in the distance.

As an experiment observe the colour relations on a very dark, stormy night between the sky on the horizon and the land adjacent to it. The land will almost certainly seem much blacker. Move your eyes up to the zenith and you will still see a very noticeable contrast between the blackness of the land in the distance and the lighter greys of the sky.

Weather conditions, of course, alter the character of the sky completely. In certain situations, fog, for example, the sky is virtually obscured completely. Fog diffuses the colour of everything. In a dense fog the landscape may well not be worth painting unless there are some powerful forms and shapes which push through the atmosphere.

However, a partial fog or light mist can present quite delectable subject matter for the watercolourist. The softness and subtlety of colour and shape seem ideally suited to the medium. The fuzzy images produced by wet-in-wet techniques are particularly appropriate to the merging of colour and form seen in foggy landscapes. Use the particular characteristics of the watercolour medium to help you with special effects. Rain falling in the distance, for example, can be suggested by applying a streaky wash over the basic wash at an angle to the edges of the paper. A spray of tiny drops of water from your brush onto the wet surface can indicate feathery snowflakes. Do not be afraid to experiment and try out your own ideas. They may well work!

Seascapes

Not surprisingly, watercolour is in many ways the perfect medium for painting the idiosyncrasies of water itself. But the painting of seascapes

Left: Water, with its wonderful reflective surface provides a constantly fascinating subject, especially for the watercolourist. La Rue du Soleil *by Charles Rennie Mackintosh (1868–1928) is a fine study by the gifted Scotsman. He is usually known for his fine architectural work, and as the most talented British exponent of Art Nouveau.*

or any other watery landscape in watercolour is by no means a straight-forward matter. Water is constantly changing substance. It can, in certain conditions, appear to have immense bulk and form, as in the great rolling waves of the ocean, for example. In others, for example, in rain or the spray of a waterfall, it appears quite insubstantial. Water has two qualities which make it at once challenging and problematical to any artist: they are movement and reflectivity. Fortunately, they do not ordinarily occur together. Calm, still bodies of water are immensely reflective, whereas a bubbling stream reflects only flashes of sunlight, perhaps nothing more. Even the calmest pond, however, has a certain amount of movement in it. The artist can suggest this by painting in a few gentle swirls on the surface or by introducing a shimmer into the reflections. Notice how water on some other surface, a pavement or street, for example, also creates vivid reflections. Observe, too, how reflections are not only mirror images of their sources but are also usually darker and less defined. They may well be distorted by the angle of the surface or by a barely perceptible movement in the water.

Rivers, oceans, streams and waterfalls should always be painted with the direction of the movement of the water in mind. This must be clearly defined in the painting. One way to do this is to direct your brushstrokes in the same direction, taking account of rocks, stones or obstacles in the path of the flow. Observe how the water itself negotiates these objects and do likewise with your brush. The frothy, white tips of waves and water splashes can be effectively rendered with drybrush techniques. As to colour, do not begin with preconceived ideas, such as 'the sea is blue'. The sea is, in fact, colourless. Its apparent colour is the result of reflected colour, particularly from the sky, and this in turn is affected by objects in the sea such as rocks, sand-banks and so on. Homer described the sea as 'wine-dark'; to others it may seem a deep brilliant green, or a hazy blue-grey or brown and muddy. Your concern is only how it appears to you.

Mountains and rocks in landscape

Mountain scenery can be breathtakingly beautiful—and the majesty of the scene before him can often overawe the inexperienced painter. Consequently he is tempted to simply copy what he sees, and this often results in a typical 'chocolate box' effect, crowded with far too much detail, and utterly dependent on the raw influence of the panorama. To avoid this trap, stand back and look at the mass of shapes before you as critically as possible. What you are looking for are the key elements of composition and design, and you should always be considering how to simplify, and how to control the scene into a definite pattern.

If you think about it, underneath the covering of soil and trees, mountains have a distinct geological structure. If you stripped off this

Opposite: Constable's rapid 'note-taking' technique is brilliantly demonstrated in this picture called A Waterfall. *He was the strongest advocate of the primary influence of nature, and made many swift sketches of the passing phases of the seasons and the weather.*

89

covering, you would see how they were formed—perhaps by volcanic upheavals, or faulting, which produces all kinds of fascinating angles. Slabs of rock may be piled up at odd horizontal angles, or whole section of the earth may have subsided, to make almost perfectly sheer-sided structures. These geological details dictate the line and rhythm of the mountain landscape, and also the shape and texture of the individual rocks on the surface.

Composing the picture

Generally, the most successful paintings of mountains are either from a very long distance, where you are basically working with shapes and colour, or else really close up, focusing on some particularly dramatic element on the mountain face, or right inside a valley, where you can work with the texture and structure of the rock itself. If you are painting at a distance, use the sky area intelligently. You can either have more

Below: An Alpine scene by the English eighteenth-century watercolourist John Martin. It became fashionable for painters to travel long distances in search of high ground and rugged mountain landscapes.

sky than land, or land than sky, but avoid making them equal in emphasis —your picture simply won't be as interesting. If you are focusing on one mountain in particular, make sure that the lines from the foreground lead toward it, preferably with curved lines rather than straight. You don't want to rush the viewer through your picture. Another way of establishing your focus is either to paint it in the darkest tonal colour value, or else in the lightest. Similarly, on close-up views, select a definite focal point, a particularly interesting group of rocks perhaps, but avoid placing them at the centre of your picture. Do the most detailed work on this area, and select only the elements of the foreground which balance and enhance the focal point, and avoid painting everything that you see in the foreground. Again, select the areas which guide the viewer gradually to the detailed point that you have selected.

Painting outdoors

Trees and shrubs are a major element in landscape, and all too often we take them for granted, because they are such familiar features. Yet they add an entirely unique quality of texture and composition to your painting, and you should become as well informed as possible about the different varieties. Begin with a detailed approach. Look through books on trees and shrubs, and study them until you can easily identify the more common species. Now you need to build up a properly annotated sketchbook by going outdoors and drawing as a regular exercise, covering as many seasonal variations as possible. Use pen and pencil, and if you are able, add colour references too. The main purpose of this is to build up your confidence and skill, so that you are able quickly to identify the kinds of trees and shrubs in the landscape, even though you may be looking at them from a distance.

With this detailed knowledge at your disposal, you should be looking for the individual shapes of different kinds of trees and shrubs. Never paint them as vague, impressionistic blobs, try to use their shapes as part of the composition of the landscape. One exception is when you are painting hedges, especially around fields, where they have been trimmed to a regular shape. Here you can use that regular shape as a feature in itself. Left to grow naturally, trees have distinct silhouettes, (fig. 1). If you want to have a tree or shrub prominant in the foreground, you can concentrate on the detail of trunk and leaves, while those in the distance will have to be identifiable from their individual outlines. When you paint trees at a distance, first sketch them lightly in pencil, then, using the lightest colour value, paint the over-all shape of the foilage (remembering that the silhouette is most important) in a flat wash. While this first wash is still wet, lay in a second wash in a darker colour value to express the shadows. Always keep in mind that light comes in from above, and use this as the lower part of the foliage. This second

Above: Fig. 1 shows some of the many distinct variations that can be achieved on a basic tree silhouette

Below: This exquisite watercolour of a merlin hawk is by the Victorian novelist Emily Bronte.

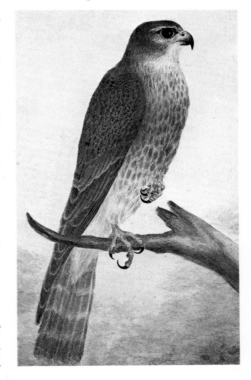

wash blends in wet-in-wet. When the two washes are dry, add a little drybrush for textural interest, then using a fine brush, finish with the details of the branches and trunk. While you are compiling your sketch book, you can try this technique with one colour, concentrating on the light and shadow effects for different species.

Nature sketchbooks

Watercolour studies of close-up views of botanical subjects have a special place in the history of painting. As early as the seventh century, Chinese artists used their exquisite brushwork to do fine flower studies, and the Japanese continued this tradition. The recent popularity of such books as *The Country Diary of an Edwardian Lady* show how beautiful this careful, detailed work can be, for small plants are part of the endless diversity of nature, and each has its individual appeal. If you

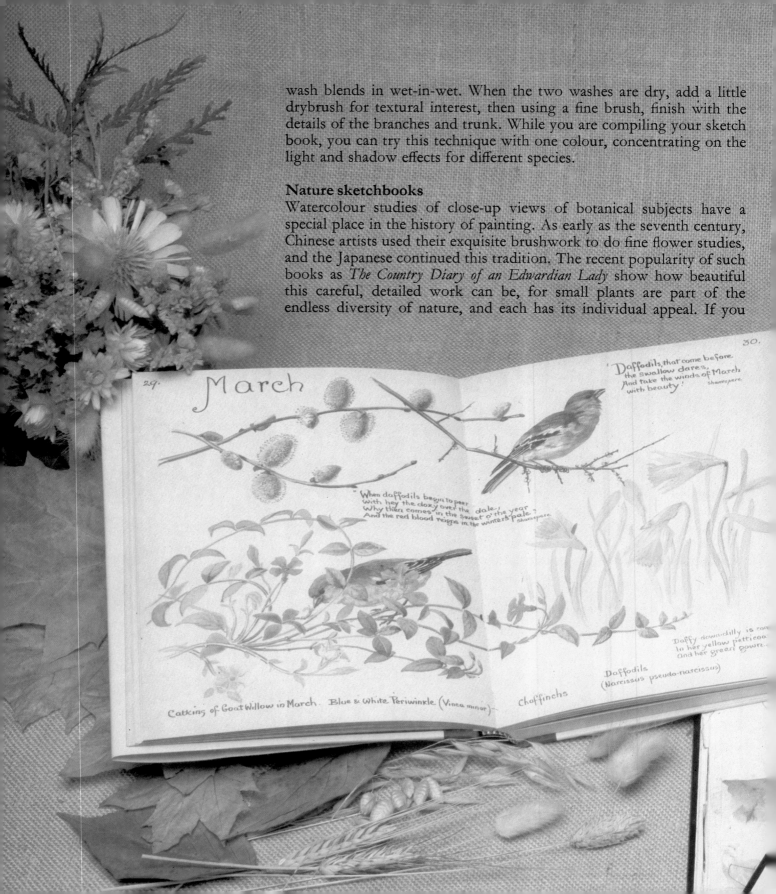

29. March

30.

'Daffodils, that come before
the swallow dares,
And take the winds of March
with beauty!' *Shakespeare*

" When daffodils begin to peer
With hey the doxy over the dale,
Why then comes in the sweet o' the year
And the red blood reigns in the winter's pale." *Shakespeare*

Daffy down-dilly is come
In her yellow petticoat
And her green gown.

Catkins of Goat Willow in March. Blue & White Periwinkle. (Vinca minor). Chaffinchs Daffodils
(Narcissus pseudo-narcissus)

visit a good antiquarian book dealer, you will find a whole section of old books which specialize in these watercolour illustrations. Many are quite formal in approach, and stress botanical detail rather than the pictorial effect. However, these precise studies of herbs, flowers and other small plants are works of art in their own right.

You really need an excellent eye for detail if you want to paint small plant subjects successfully. It would be wise to keep a special sketchbook to fill with your pen and pencil drawings. Remember that you can explore your own garden and public parks as well as the countryside itself. This will provide you with essential basic knowledge, and you'll soon discover that in addition to flowers, weeds and grasses can make enchanting subjects in themselves. As you need a basic foundation sketch for a painting, these preliminary studies are invaluable, and they also teach you to sketch quickly.

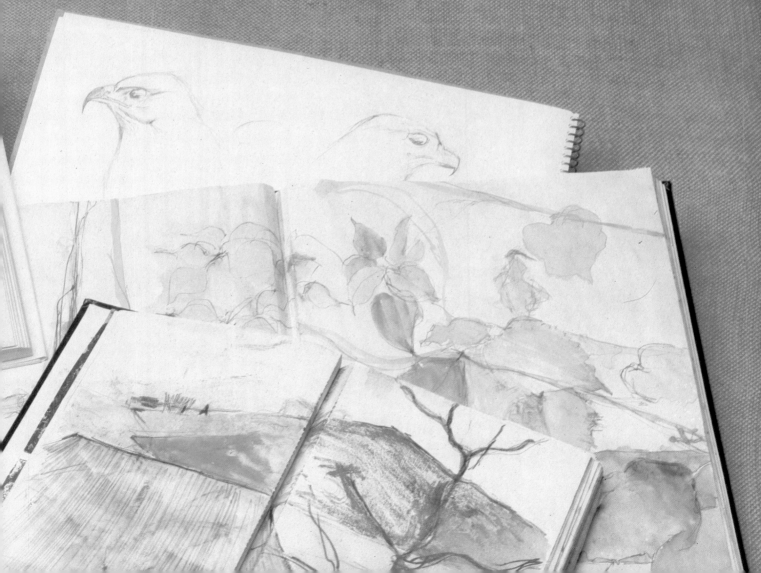

Painting flowers

When you paint flowers, the main danger to avoid is that of making your finished picture look like a photograph. Your painting should have a completely fresh, spontaneous feel—and you can start by looking at the blooms themselves. Look at how their shape is formed by the arrangement of the petals, and emphasize this deliberately. How are the flowers and buds set on the stem? Do the leaves fall in a particular way? You can exaggerate the line a little. If you are painting only one flower, try to highlight it as much as possible. The paper should be kept very small,

Below: Castle by the Sea *by Raoul Dufy. The artist's direct, immediate style of application is used to great effect in painting the palms and tropical flowers. His bold, loose brush strokes evoke a mood of gaiety and natural abundance.*

94

so that the flower can be almost life-size, and is not buried by the background. A useful approach is to focus on the petals of the flower first, drawing them in lightly with pencil. The background should be laid in with a flat wash, remember that it should be kept unobtrusive. After you have laid down the background wash, add some mere suggestions of details of any foliage and ground textures.

Now you can concentrate on the plant itself. Paint the leaves and stems, noticing where the shadows fall. Finally, paint the flower. You will need the purest colours to achieve the radiance and 'bloom' of the

Below: In complete contrast to the Dufy (opposite) this eighteenth-century botanical illustration of a nasturtium is utterly careful and precise in its detail, yet no less beautiful in its impact.

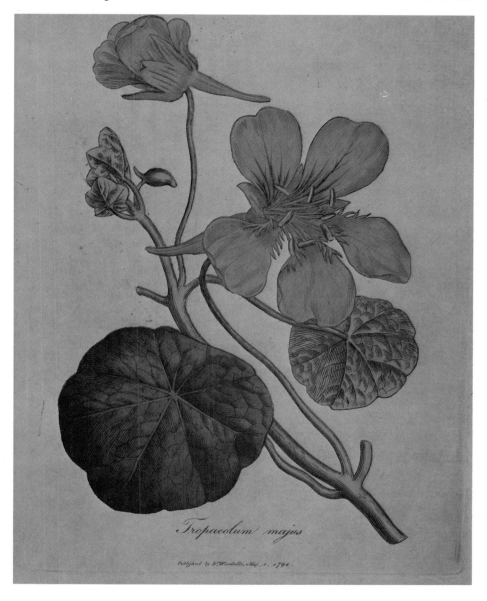

Tropaeolum majus

Published by D.Woodville, May 1. 1794.

petals. This takes a lot of practice to achieve. Spring flowers are best painted with transparent watercolours to suggest their fragility, while the sturdier blooms of summer and autumn can be well expressed in gouache. When painting white flowers, you might add hints of blue and red to create the delicate shadows.

Weeds and grasses

Humble weeds and grasses can be beautiful—think of Queen Anne's Lace for example, which has superb dramatic form. You can either choose to do individual studies, or do a picture which shows the pattern of weeds and grasses interlacing. Again, draw in the main features with pencil, then lay in the background wash. This might be green and brown. Then pick out some of the more distinctive plants to act as the central focus of your picture, and paint in their detail. Finally, add the interlacing grasses and smaller weeds. These can be scratched in on top of gouache with your fingernail, or a sharp-edged object like a razor-blade; this is an excellent way of capturing the intricacy of the intertwining plants.

Portraiture

There is a common misconception that watercolour is unsuited to portraiture. As a result many students avoid the medium for this form of expression without ever having tried it. In fact, watercolour is ideal for spontaneous, informal portraits (of family and friends, for example) so it is worth experimenting with it to find out what you can achieve. To begin with use lots of small sheets of paper, rather than one large one, and resign yourself to the fact that many of your initial attempts will be disappointing. Many beginners are especially anxious to achieve likeness, but it's best not to worry about this at first. Just concentrate on doing a good painting. The likeness will take care of itself in time as you become more experienced and more observant.

The basic construction of the head should be your fundamental concern. Likeness depends far more on this than on small variations in the shape of particular features. Although human beings communicate through facial expression, feature movement is of little significance for the portrait painter compared to the dominant shape of the skull.

Approach the painting as a sculptor would and try to build up the three-dimensional mass of the head. The skull is covered by a web of muscles moving across sections of the surface and into its structure. These muscles are continually moving, flexing, relaxing and changing shape as you observe, talk, breathe and turn. Any action changes the appearance of the head although the fundamental bone structure remains constant. Try to become aware of what is going on underneath the skin and hair of your model as you are doing the painting. This will

Opposite: A clump of weeds is transmuted into a watercolour and gouache work of stunning beauty. The Great Piece of Turf (1503) is one of Albrecht Dürer's masterly botanical studies, and is typical of his loving, perceptive vision of the natural world.

97

help you to understand and analyze the information coming to you through your eyes—why a certain movement appears to cast a particular shadow or throw a hitherto unnoticed feature into highlight and so on.

The ability to draw well is particularly important in portraiture. Before you even attempt a painting it is advisable to practise drawing heads as much as you can, until you feel confident that you understand the basic construction of the head's anatomy and the peculiarities of its most important features. You will not use much of the detail in the paintings but the understanding you have gained through the drawing exercises will be invaluable.

If you wish to attempt a self-portrait certain practical considerations should be taken into account. You should be able to work in comfort and in a position where there will be a constant source of light. A bedroom may well be the ideal place. It provides some privacy and there is likely to be a large mirror perfect for the task. Position yourself in front of the mirror so as to establish a strong contrast of light and shadow and also to allow for a minimum of movement between board and mirror. This goes for any working situation in fact. It is amazing how often people position themselves in such a way as to necessitate a considerable movement from subject to board.

Fortunately, the very nature of the watercolour medium, whereby the board is kept almost horizontal, facilitates an economy of movement which is impossible when working in oils. Rotate yourself in front of the mirror to see what changes occur to the shape of the head from full face to three-quarter view. Observe which angle most clearly describes the surface. A full face emphasizes the basic geometry of the head, but does not easily allow for a clear understanding of the spatial movement from the chin across the mouth, nose and forehead. The three-quarter view allows for a clearer understanding of these elements. Pose yourself or your model under a single constant light source so as to obtain simple straightforward shadow shapes. Position yourself about 1 m or 1 yd from the mirror (or your subject); this distance will enable you to see the smallest facets of the head clearly. Use a fairly smooth paper allowing for fine linear detail when necessary.

Begin by constructing the over-all shape of the head, mapping in quickly with a fine sharp 2B pencil the dome of the skull, the relative flatness of the side of the head and the shallow curve of the forehead. Look critically at the various points on the head which remain constant: the cheek bones, part of the eye socket and the bridge of the nose. These ridges of bone provide a basic foundation upon which you can build. Watch how the muscles operate in the neck, helping to support the head and give it mobility. Having established the basic three-dimensional shape of the head, begin to pinpoint the position of the mouth, nose and ears, relative to each other. Establishing the correct eye level is critically

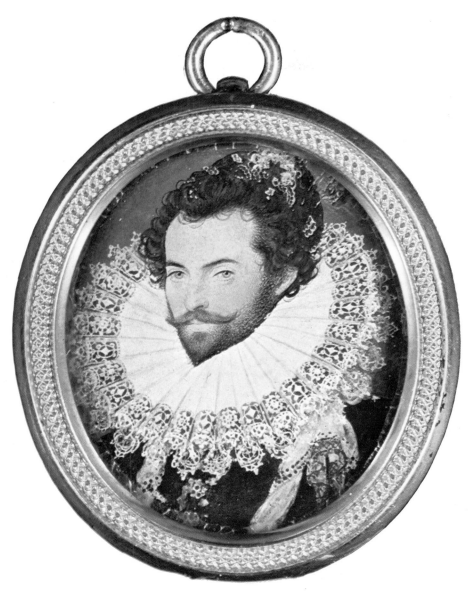

important. Observe how the relative positions of eyes, ears and mouth are quite different on an adult head from those on a child's. The eyes, like the nose and mouth, are positioned on a curve around the front of the head and have a slightly forward tilt which you may not have noticed. Notice, also, how the shape of all these features is radically altered depending on the angle of the head. Your initial sketches should simply suggest these basic shapes and proportions. Do not attempt to fill in too much detail at this stage. The details of the individual features will be completed with your brush and washes not your pencil. A

Above: This Elizabethan miniature of Sir Walter Raleigh, painted by Nicholas Hilliard is an excellent example of a favourite tradition of portraiture.

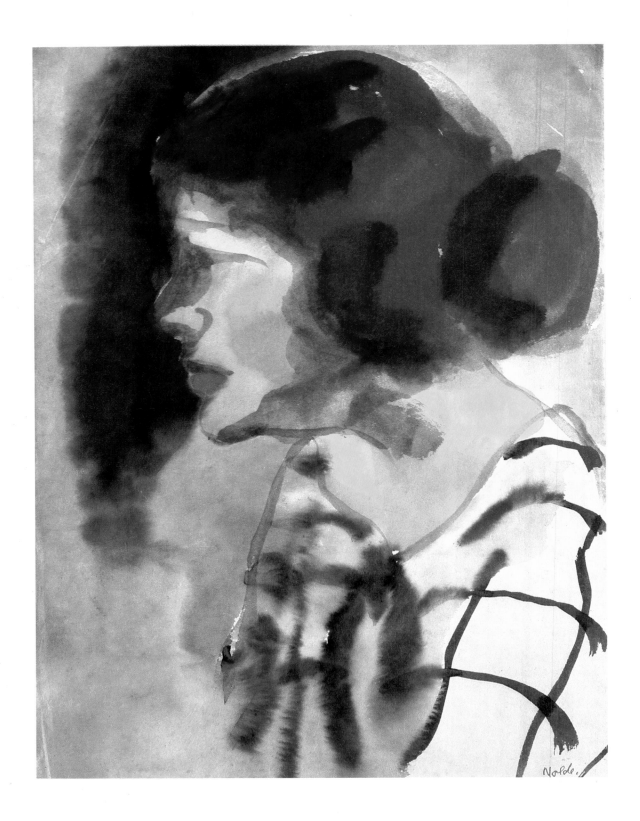

common mistake is to deal first with the features and then build the rest of the form around them. This is like trying to put a roof on a house before constructing the walls. In the finished portrait these details may well be very indistinct. The eyes in shadow, for example, would not be more than a blurred shape with no sharp edges or definite detail. Too often information is included which cannot actually be seen but is known to exist.

The hair can often pose particularly intractable problems. Many artists spend ages trying to capture its soft elusive texture with the result that the picture becomes overworked and loses its spontaneous qualities.

Opposite: An evocative portrait in watercolour painted c. 1933 by the German Expressionist painter Emil Nolde. Nolde's extraordinary ability to handle colour is well illustrated. Below: A pencil and watercolour study of people's faces called Sunday Afternoon. *Painted by Richard Lindner in 1954, the work has a very powerful quality.*

Right: Self portrait in watercolour by Edward John Gregory, (1850–1909).

There are a number of things to watch out for. The boundary between the hair and the skin should never be too harsh or clear-cut. Soft, irregular transitions are what is called for. This is much more difficult to achieve with dark-haired subjects than with blondes. Remember also that even the darkest of brunettes rarely has absolutely black hair, just as the fairest of blondes often has quite substantial patches of dark colour among the golden strands. The texture and highlights of hair can be suggested by a number of techniques, drybrush, for example, or use of the tip of the brush handle or your fingernail to scratch out light lines on the wet surface.

Colour often proves a problem in portraiture. For this reason it can be a good idea to begin your experiments with shades of one colour, black, for example, or sepia. This will give you the opportunity to improve your techniques before tackling the problems involved in colour. As mentioned in the chapter Handling Colour, human skin is particularly receptive to light and it is very difficult to capture the myriad subtle changes of tone and colour which any skin surface exhibits. Naturally most beginners are particularly concerned about how to mix

flesh colour. Unfortunately there is no simple answer to this problem since there is no one flesh colour. As a general rule a mix of Cadmium red and Cadmium lemon will produce a basic flesh tone. Some people prefer to use a yellow ochre rather than lemon. You must experiment to find out which you prefer. Remember a touch of yellow goes a long way. This will provide a very healthy colour. For more sallow skinned people add a little blue or green to the mix to mellow it.

Figure Painting

The structure of the human body has such infinitely subtle variations that it presents the greatest challenge of all to the artist. The problems

Left: One of George Grosz's beautifully observed figure studies called A Married Couple. *Notice how he has used the same baggy outline shape to depict them both.*

Right: Egon Schiele's study Standing Nude with Crossed Arms *is a stunning example of flowing line and dramatically used colour washes.*

posed are much the same in a general sense as those presented by portraiture. The solutions to the problems are therefore related.

All too often the beginner is obsessed with detail but, as in portraiture, it is advisable to concentrate on gesture and attitude rather than on specific features. Make the subject of your picture the way the model is standing or sitting or reclining. Pay as much attention to the position of the model, the lighting and the colour scheme as to his or her individual features.

The importance of the sketchbook cannot be over-emphasized. It is essential to prepare yourself for figure painting by gaining as much understanding, through observation and drawing, of how the human body operates.

When using a model, place him or her in as comfortable a position as possible and one that is easy to hold while you make your studies. In a reclining pose the muscles are subjected to little tension but that is not to say they are inactive. The seated figure relies more positively on the vertebrae and attendant muscles; the legs help to maintain the position, but the chair, stool or seat is the chief means of support. When standing, the figure exhibits a tension throughout itself; muscles change their shape and nature considerably. Establish the major proportions of the figure before attempting to capture the details. Pay special attention to the relative proportions of the head, torso, arms and legs, and notice how these proportions are quite different in human beings at different stages in the life cycle. If the figure is seated with legs towards you there may also be problems of perspective and foreshortening. Sometimes it helps to place the figure against a familiar background containing simple constants—a door, chair, window, and so on—against which you can measure more easily the new elements of the subject. Be especially careful about establishing scale. This can be avoided to some extent with landscape but not with figure painting. If your model is clothed, observe the way the folds and creases in the materials drape over and around the body. Simplicity of approach is, as always, the keynote of success. A few well-placed strokes of the brush can suggest the movement of soft fabrics most effectively.

Still life

Still life has never been a particularly popular subject with watercolourists, possibly because the characteristics of the medium have always been identified with landscape. Also, it is an undeniable fact that oils are better able to reflect the wide variety of textures, depths of colour, and materials of the groups of objects used in 'set pieces'. Still life artists deliberately choose and juxtapose china, glass, fabrics, fruits etc. in order to express the full range of their expertise.

There is no reason why the watercolourist, who has gained some

Above: One of Blake's illustrations from Paradise Lost. *This shows Satan arousing the rebel angels.*

Above: Although still life has never been regarded as the ideal subject for watercolour, some artists have produced fine still life studies in the medium. Here is an example by the master of the genre, Cézanne—Still Life with Apples.

sense of his brushwork and colours, should not paint beautiful still-life compositions. Cézanne shows how successful watercolour can be in this tradition in his painting *Still Life with Apples.* A more contemporary example is Daphne Sandham's *Still Life,* where bright, primary colours are used to dazzling effect.

Very few still life pictures are 'found' by the artist just as they are. The objects and setting are cunningly chosen to contrast and harmonize. You'll find that in your search for suitable components for still life, you develop quite a magpie instinct. Common household items like jugs and pots in earthenware, pewter, copper or porcelain can be placed on a scrubbed wooden table, alongside glowing fruits, perhaps an unusually shaped bottle, maybe even a dish of golden butter.

For a still life scene outdoors, you may find a straw hat, gardening basket, flowerpots, some small gardening tools, and arrange them on a wooden chair. You could add a fine cabbage or cauliflower. These are simply suggestions, of course. In fact, you should avoid crowding your

Left: A bold contemporary still life in watercolour by Daphne Sandham.

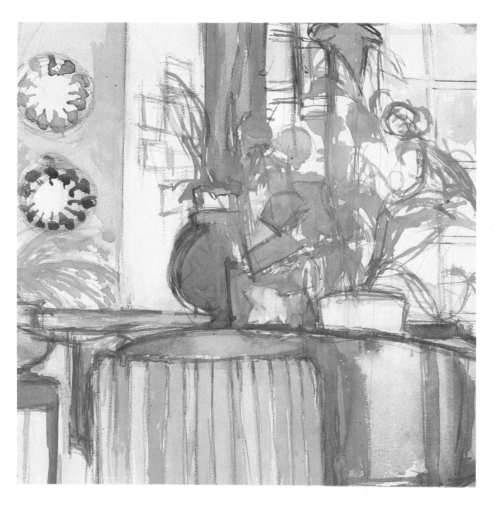

Above: The artist Jane McDonald has arranged the elements in this charming watercolour still life to bring out the contrasts in colour and texture to the finest effect.

composition, and concentrate on really strong, simple design. Some of the most beautiful still life pictures have only a few objects in them. Keep arranging your group until you are satisfied with the composition, and when you are working indoors, experiment with different ways of lighting the group.

Once you are happy with your arrangement, sketch in the major shapes lightly with pencil. Apply the background wash first, and then work on the details of the objects themselves. The textures and surfaces are vitally important, they provide a sensuous dimension to the work, making each item seem to breathe a life of its own. Work carefully on shapes, keep on checking that you have the correct fall of shadow. Also remember that your colours will influence each other quite strongly, and you can exploit this very well in still life. Where you need a thick impasto effect, you can use the aquapasto jelly medium to gain a really thick, creamy texture.

Techniques

The development of techniques in painting tends to grow as much out of trial and error in practical work as it does from theoretical information. It is very important to discover your own particular skills and aptitudes through constant experimentation. The beginner can be guided in the direction of ideas, but it is how the individual puts these ideas into practice that counts. If the following techniques don't work for you, then don't be discouraged, they are simply provided as interesting suggestions for further exploration. This chapter introduces several new ideas, including a discussion of line drawing with inks and watercolour washes, monochrome work, tempera painting, and a whole range of intriguing ways of adding texture and unusual elements to your work. It should be stressed however that you must avoid becoming dependent on 'the tricks of the trade', and constantly develop your basic painting skills, otherwise your work will be based on special effects rather than on a sound foundation of good observation. This is not meant to put you off using extra techniques—in fact they can be great fun to try out—but you should beware of over-indulgence.

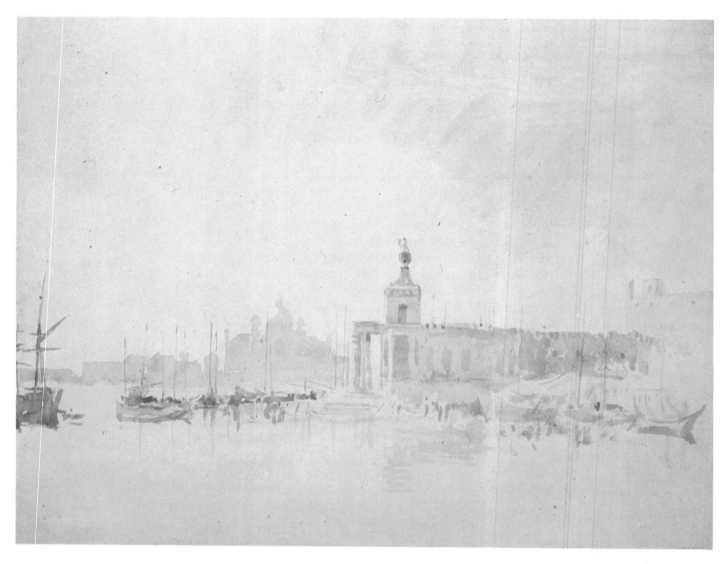

Above: One of Turner's beautiful views of Venice. Notice how he has used the brush to draw in detail as well as to apply the fleeting, delicate washes.

Line drawing and watercolours

Although line drawing can be described as a separate skill from painting, the greatest painters have always been superb draughtsmen. The ideal level of skill to which the painter aspires is such excellent competence at drawing, that the main outlines of the work can be applied straight from the brush, so that in fact he draws with the brush itself. This level is only reached when the artist is so fluent in his draughtsmanship that line work is completely natural to him. Major painters like Turner, Constable and Girtin all had this wonderful quality in their watercolours, their work seems to have flowed effortlessly from the brush. Many watercolourists tend to emphasize line work rather than blending it into the

wash or body colours. For example, Klee uses pen and wash frequently, using the line work as a very strong element in his pictures. In his work called *They're Biting* , the fine outlines of the pen work and the delicate nuances of the wash colours work together to create both a dreamy translucent quality, and a witty, humorous touch, produced by the graphic line. Line is a vital element in cartoon work; you will see this very well expressed in Cruikshank's cartoons, where, again using pen and wash, he creates a great deal of action and humour with his lively, vigorous pen work and bright primary washes. Blake uses his long experience as a draughtsman and engraver to enormous effect. In many of

Left: Line is a crucial element in this pen and wash painting by Paul Klee called They're Biting.

Right: Cartoon work is a medium in which line is predominant—washes are merely used to strengthen the visual drama. This cartoon is by George Cruikshank (1792–1878).

his paintings, line is very much the dominant element, and the washes are often used just to strengthen the visual drama.

Improving your drawing skills

Obviously the preceding discussion on excellence in line drawing does not imply that you should abandon your career as a watercolourist simply because you can't draw like William Blake. However, you will soon discover for yourself that any restrictions on your ability to draw may frustrate your progress. You can certainly gain some fundamental principles from books, and if you are able to find a good drawing class, so much the better. Classes in drawing will help you in many ways— you'll find that your sense of composition improves, and most of all you'll find that you gain much more confidence in putting down your preliminary sketches, and the thought of learning to draw straight from the brush will not hold so many terrors. You will be constantly en- couraged to do lots of fast sketching exercises, and by learning to work quickly, you'll improve your painting.

Using pen and inks

The foundation of pen and wash work lies in learning first how to exploit the medium of line. A good way of starting is to use pen and

inks, which, as we have mentioned before, are made up from dyes. They are available in a wide range of colours, and you can do your line work with the ink at full strength, and then dilute it for your washes. You may find that some inks tend to separate into granular patches if you are using ordinary tap water. The best way to overcome this problem is to dilute the inks with distilled water, which you can buy at any pharmacy. Another problem with inks is that they have little resistance to light, and will fade after a time. Ink washes are applied in exactly the same manner as watercolours, and can be used both for monochrome work and for traditional colour ranges.

Pens

There are many kinds of pen suitable for line work. Look at the selection in your art supply store, and choose one that can be fitted with different sized nibs. This provides you with a wide choice of thickness and strength of line. You could also supplement the ones you buy with some home-made pens, which you can make from bamboo and quill feathers. A home-made bamboo pen gives an effect very much like Chinese calligraphic work, and is great fun to use. To make one, select a piece of ordinary garden bamboo cane, and cut a length of about 20cm (8in). Make sure that you cut well above a knot. Then, using a Stanley knife, cut the top at an angle, and trim down the sides of the angle to make a point. Finally, slit the point to make the ink channel. (See fig. 1). You can also make goose-quill pens by the same method, visit your butcher, and ask him for some quill feathers. After a while, quill pens soften at the ends, but you can re-cut several times. Once you've

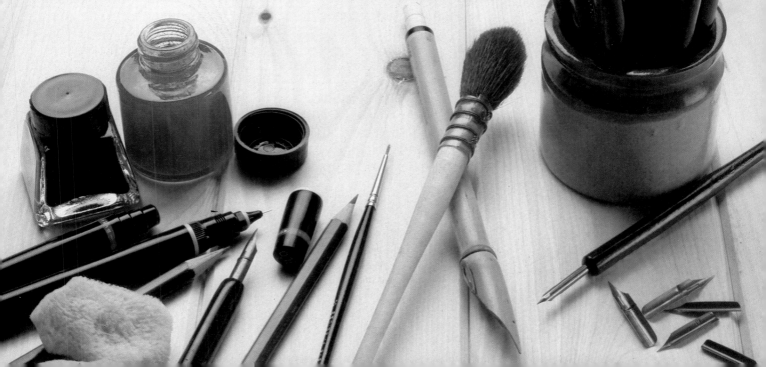

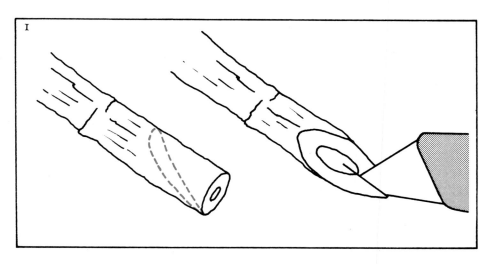

Fig. 1 Cutting a home-made bamboo pen.

practised using these pens with your inks, you'll find that you'll really enjoy working with them, and discovering their particularly fine qualities.

Monochrome work

Monochrome work simply involves working in one colour, and exploring all the nuances of that one hue throughout the painting. You will find that this is a particularly challenging area of work, and it will show you how much the painter depends on colour to provide texture and depth to his work. When using one colour, you have to create all these effects through light and shade, and you will be amazed at how beautifully haunting and subtle your work can be using this medium. It is possible to work monochrome both in ink and in watercolour. A really fine example of lyrically perfect ink and wash monochrome work is found in Samuel Palmer's *A Rustic Scene* (fig. **2**). Here he combines a strong drawing technique with an incredibly suggestive use of shade and tone, exploiting the full range of shading from only one basic colour in a truly breathtaking picture.

One of the problems about monochromatic work in the hands of a beginner is that it can lack texture. Later on in this chapter, you'll discover a whole range of techniques for adding texture to your work, and you can select the ones most appropriate for your painting.

Impasto

The use of impasto is very new to the watercolourist, for the traditional pigments have not been suitable to mix into the thick, creamy consistency of paint needed for working. In the chapter on materials, the recently discovered jelly medium known as aquapasto was mentioned, as well as advice on how to mix it with various kinds of watercolour

paints. If you are going to work with impasto, you should first of all make sure that your paper is strong enough to hold that density of paint without cracking. You might consider cardboard, especially if you intend to do a large area of impasto work. Don't forget also that the technique uses a large amount of paint, so mix up a generous amount on a large surface palette—a white dinner plate is ideal. Once you have mixed your impasto to the recommended proportions, it can be applied either with a hogs' bristle brush, or with a palette knife. Never use a sable brush with impasto, as it is likely to be ruined.

Working with such a thick texture of paint can be fascinating, and you can try out all sorts of effects, including stippling. This involves building up areas of colour with lots of small dots applied with the tip

Below: Ink and wash monochrome work can be used to produce beautiful haunting effects when used with skill. Fig. 2, Rustic Scene, is by Samuel Palmer.

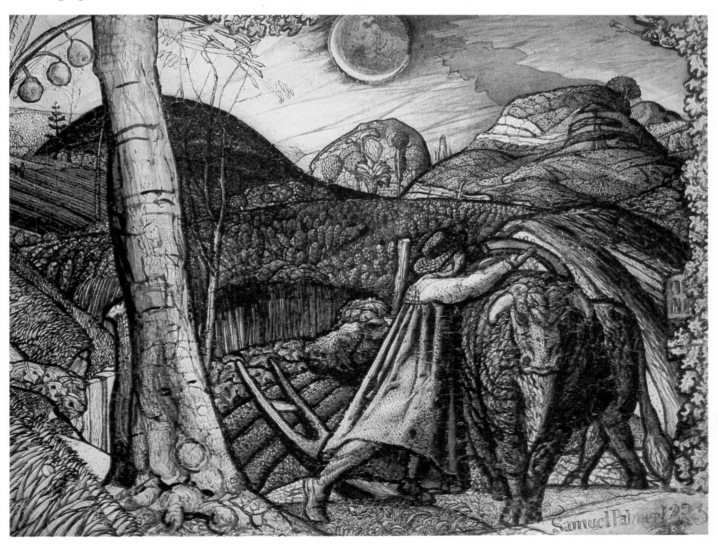

of the brush or knife, either with a mix of colours, or with shades of one. It is basically a pointillist technique, as used by Seurat in his wonderfully evocative oil paintings and is also used with tempera, as discussed later on. It is thoroughly absorbing work to do. Now that aquapasto is available, even a traditional oils technique is possible for the watercolourist to employ. Impasto is also an ideal surface on which to use the following technique, known as sgraffito.

Right: This watercolour called The Bay of Glasstown *is attributed to the Victorian novelist Charlotte Bronte. The stippling technique used is very reminiscent of the pointillist method.*

Sgraffito

Sgraffito is simply a method of cutting or scratching the surface of your paint to reveal the ground. Depending on what instrument you use to do this, various effects can be achieved. For example, you can use a razor-blade to cut out tiny strips of the colour to make highlights, perhaps to suggest light catching an area of glass or metal. The flash of white paper suddenly revealed can be really vivid and powerful. You can also scratch or cut with scalpels, knives, sandpaper, pieces of cuttlefish, palette knives—whatever you can think of. Always experiment first however, and always take care that you don't damage the surface of your paper. Sgraffito should be a well controlled technique. A slight variation in effect can be achieved by using a very soft rubber eraser. This is particularly suitable for transparent watercolour also; if you want to achieve an effect like rays of sunlight, for example, you can draw the eraser gently along the dry surface colour. Don't rub too hard, or else you'll damage your painting.

Wax resist

Wax can be used as a resist element in a variety of ways. You can apply it on an area of wash, and then apply another wash over it to achieve an interesting mottled effect. You can experiment with variations of the amount of wax and colour used, and also repeat the resist in different areas of the painting, waxing over various layers of colour. The simplest form of wax to use is an ordinary white candle, but you can also try out different coloured wax crayons. Another variation would be to make a wax relief rubbing, and then float colour over the surface texture. Try it first on a small piece of paper, perhaps with a coin as the relief surface. Another way of exploring wax resist is with heelball, which you can buy at art supply stores. It produces an extremely waxy surface, which will not take paint. To reduce the waxiness, take a piece of clean blotting paper, and press with a warm iron. This will remove the surplus wax, and allow a more controlled wash to be laid over the surface. A brilliant example of wax resist used to fine effect is the work *Pale Shelter Scene,* by Henry Moore (fig. 3). Here the artist has used wax to create superb highlights, giving a rather ghostly effect to the work—a technique he frequently uses.

Isolation

Often you will need to keep areas of white ground completely free during your painting. This is possible by using a technique known as isolation, which involves covering the chosen area of ground, applying your colour, and then removing the protective covering material. Some artists use masking tape, which is fixed in place before the first wash is applied. The main problem with this method is that occasionally the wet

Above: Strange, ghostly highlights are created with wax resist, one of the favourite technical devices of Henry Moore. This study is called Pale Shelter Scene *(Fig. 3).*

paint seeps under the edges of the tape and, also, there is the danger that the surface of the paper could be damaged when the tape is peeled off. A good alternative would be to use a latex rubber adhesive. This can be brushed on the area that you want to leave white, then, when the colour washes have dried thoroughly, it can be rubbed off with a piece of soft art gum.

Lifting off colour

The previous isolation technique preserves areas of completely untouched paper, which can then either be left white, or washed at a different density from the rest of the painting. There are other methods of bringing areas of light into your work however. The basic technique used is that of lifting off layers of colour to express the lighter tones beneath. Various materials can be used to do this, ranging from brushes to absorbent items such as blotting paper, tissues, paper napkins etc. Before attempting any of these techniques on a finished painting, try the methods out on pieces of pre-painted paper. Some can be used when the paint is dry, others while the work is still wet.

Dry surfaces

When you have a dry surface, one method of lightening an area is to dampen a soft large brush (your mop would be ideal) and brush the area you choose lightly. Rinse the brush and repeat. Try this several times, giving the surface a little time to settle in between, then, when most of the pigment is cleared, blot the area with a tissue. You can experiment with various sizes of brush, perhaps exposing only brush stroke areas. A stiffer brush, such as a small stencil brush, can be used for a quick 'once-off' effect, re-wetting the area only twice and then blotting. To control and vary the shape of the area that you are exposing, you could use a small sponge and various masking agents. Firm cardboard can be held to make crisp edges while you are wetting and blotting, or you could make stencils in various shapes, wetting and blotting through their outlines.

Wet surfaces

While the paint is still wet, you can try various ways of removing layers of colour. A medium-size brush, used barely damp, can brush off pigment, and you can vary the way you apply the brush, for example press it on in a circular motion, or with short, flat strokes. If the paint is too wet, this method will not be successful, but you will soon learn to assess the correct drying time. Blocks of paint can be removed by scraping with a firm piece of cardboard, or any flat-edged surface. You can also mop up the paint with absorbent materials like blotting paper, natural sponges, tissue paper, and textured paper napkins.

Adding texture and pattern

By trial and error, painters have discovered a wide range of methods to create interesting patterns and textures on the watercolour surface, either to enhance or contrast with the wash. Before using any of these techniques, however, you should experiment on scraps of paper until you are really sure that you can control the method. Also make sure that they really do add to your work, and don't use them merely for their own sake. You will need 10cm (4in) squares of paper, which you can keep for future reference, labelled with the technique that you have used. You should try the techniques with both gouache and transparent watercolours.

Unstable colours

Unusual effects can be achieved by using unstable colours. These are pigments that separate while drying on paper, thus creating a mottled surface effect, Cobalt green and Alizarin crimson for example. If used with restraint, this technique can provide real visual sparkle to your work. Another interesting colour to use for this effect is Davy's grey, which is a relatively slow-drying paint, manufactured from ground slate. Lemon yellow also gives a mottled appearance when laid over another colour, and dries to a good, strong shade.

Other textures and patterns

Waterspotting Using clean water, drop spots onto barely damp areas of colour. As the paper dries, the spots spread out into unusual patterns.

Pigment spatters Dip a damp toothbrush into your pigments, and pull the bristles back with your thumb to spray the colour onto the painting. You could mask out the area to control the shapes of the spatters.

Water spatters Dip the toothbrush into clean water and flick droplets onto the painting. Make sure that the surface is nearly dry to achieve the best results.

Cardboard stamping Take pieces of cardboard cut into different shapes, and brush paint onto them. Stamp these onto wet or dry areas of paint to make different patterns on the surface.

Other stamp materials Paint can be stamped on your surface with all sorts of materials. Try leaves, pieces of wood, whatever works to make interesting patterns.

Meshes Any materials with a mesh like gauze or pieces of wire screen can be brushed with paint and then pressed onto the work surface. Alternatively, the paint can be brushed on through the mesh.

Salt Salt can be spread onto damp paint, and will absorb pigment into the grains while drying. When it has dried, brush off the grains, and the resulting patterns left by the crystals will resemble snow or rain effects.

Sand Sand and other non-absorbent kinds of grit can be sprinkled onto

Various techniques are shown here. Opposite (top) stamping with stencils, (middle) waterspotting, (bottom) stamping with paper scraps. Above: Overdrawing with palette knife and brush; Below: Sgraffito incisions in the paint surface, made with a scalpel blade.

the wet paint. While drying, the colour will concentrate around the granules, which can be brushed off when thoroughly dry.

Ink rollers Apply paint to an ink roller, and apply to either wet or dry paint. Avoid rolling too much, or you will get a muddy effect. Use short, definite movements.

Palette knife You can use your palette knife to dab on patterns, or to drag pigments along wet or dry paint.

Tempera and gesso

As you develop your technical range, you may find yourself becoming increasingly curious about exploring different qualities of paint, and also alternative grounds to hold your pigments. Tempera painting can be quite difficult, but it is a medium which is worthwhile in itself. Tempera is basically an emulsified pigment—an extra agent is added to the basic colour to provide it with a unique texture. Throughout the centuries many kinds of emulsifying materials have been used, but the purest form is made with egg yolk. The characteristic brilliance of the colours used in medieval wood panels is typical of tempera work, and it was often used with large areas of gilding. Tempera achieves its fullest translucency and richness when laid on a gesso ground, and the instructions for making this are supplied later. As a technique, it is regaining popularity with watercolourists, though it has largely been used by oil painters as a medium for underpainting.

Making tempera

The method described here uses egg yolk as the binding medium for tempera. You can, in fact, buy ready prepared tempera colours, and although these are very good, the addition of the egg yolk provides an unrivalled brilliance of colour. You can use all the watercolour paints, though you should remember that if you use gouache, or add any white pigment, you are going to lose the unique translucent quality which is the basic strength of the medium. The egg yolk is first separated from the white, then, holding the yolk over a glass jar, pierce the membrane and let the liquid yolk drop into the jar. Discard the membrane. The yolk should not be kept for more than one day, even if you refrigerate it, its binding qualities may be affected. Once you have freed the yolk from the membrane, add about a third of a teaspoonful of water, and mix thoroughly. Place your pigments onto a palette—if you are using dry pigments, mix them to a paste first, otherwise use tube or poster colours as they are. Add an equal volume of yolk binder, and mix with a palette knife. Some pigments vary in the amount of binder they need, so you should experiment to find the correct proportions. Brush the mix onto a clean palette, and leave to dry overnight. The paint should peel off cleanly, without flaking or crumbling.

Painting method

Draw your preliminary sketch very lightly onto the gesso ground, and then apply the first tempera wash. This should be kept as light as possible, using a little colour, a little egg binder and a good amount of water to create a very pale wash. Once the basic areas of wash have been established, the structure of the painting is built up using a stippling technique, where dots of colour are applied with small brushes to amass areas of colour. Use the tempera without extra water for stippling. As long as you avoid using gouache, or an extra white pigment, you'll find that your colours have a really astounding luminosity, and it is very easy to understand why the medium is so attractive.

Left: Egg tempera is becoming increasingly popular with some modern artists. In her work The Jacobs *Suzie Malin uses the medium brilliantly, and fully exploits the rich, glowing colours typical of tempera.*

Making a gesso ground

Gesso is simply a chalk mix applied to a rigid surface—usually a wooden panel. It would crack if laid onto paper, and a seasoned wood, marine plywood, or good quality, thick hardboard would be the most suitable supports. Usually the panel is kept rather small, to avoid excessive warping as the gesso dries. Certainly for a beginner the largest dimension should not be more than 30cm (12in). The panel should be lightly sanded and sized before applying the gesso. Size, and the other gesso ingredients can be obtained from art supply stores.

To make the gesso mixture, take 25gm (1oz) of dry rabbit skin glue, and soak it overnight in 600ml (1pt) of water until it swells. Heat the mixture in a double boiler until the glue is completely dissolved, but do not allow it to boil. Remove from the heat, then gradually stir in enough kaolin, whiting, or marble dust to make a fairly thick cream. If there are any lumps, strain through a sieve. Apply to the sized panel either with a

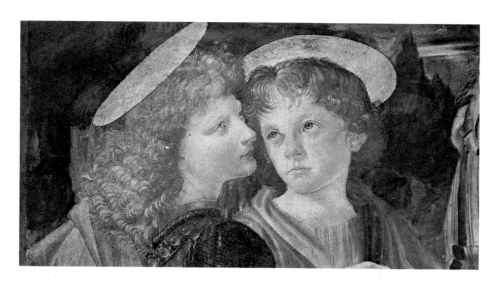

Right: Detail from The Baptism of Christ *by Verrochio. The work is painted on panel in egg tempera, a medium used extensively by the Renaissance painters to add brilliance to their colours.*

large hogs' bristle brush or a felt-covered roller. Leave it to dry, then smooth the surface with fine sandpaper. Apply a second coat, which has been re-heated, and when this is dry, sand again for a really glossy surface. Some painters use several coats of gesso to make a thicker ground. Even if you decide not to use the gesso panel for tempera work, you'll discover that it is excellent to use as a ground for ordinary watercolours, and is especially suitable for laying on thick amounts of impasto. Sgraffito techniques can then be exploited fully, since you can penetrate right into the gesso surface for extra depth and texture.

Mixed media

Given the wide range of techniques and materials that you have at your disposal, it is an irresistible temptation to see how they work together. You will already have used transparent watercolour and gouache in combination, as well as line in pen, pencil, charcoal and ink with washes. Don't forget also that pastel is an excellent additional material to use, especially with gouache; you can buy boxes of pastels at art supply stores, and they can be used for making preliminary drawings for your paintings. If you use pastels for this purpose, make sure you fix them with spray fixative before you add paint. You can also add strokes of pastel after you have laid on your colour, and they are suitable for use with transparent watercolours in this manner.

Fixing pencil sketches

A final tip from the experts: if you have no aerosol fixative to spray on your preliminary pencil sketch, paint a film of cream-free milk onto it. Skim milk is ideal. Any residual cream in the milk would resist colour being laid on top of the surface.

The Finished Painting

Decorative surrounds in the earliest visual work such as Roman mosaics were in the form of friezes, which separated one image from another and at the same time interlinked them. The richly gilded frames of Gothic altar pieces strongly reflect the architectural order of their time and also serve physically to link the wooden panels. In the Renaissance the inter-relationship between architecture and mural was often enhanced by painted architectural motifs within the mural itself. In the Sistine Chapel ceiling for example Michelangelo binds the whole sequence of images together with painted architectural friezes. Seurat considered the frame to be such an integral part of a painting that he hand-painted some of his frames in pointillist style. Framing is largely a matter of taste. In the Turner retrospective exhibition in London, at the Royal Academy of Arts, a number of paintings were displayed in really austere frames, contrasting radically with the more traditionally ornate frames on the paintings surrounding them. They looked splendid.

Today the range of frames to choose from is immense. They come in all sizes and an assortment of materials, including aluminium and plastic as well as the more traditional gilt and wood.

Many works are conceived without frames, such as the work of Barnett Newman and Morris Louis. Apart from the question of aesthetics, the frame has an important function as a means of protection, especially for the corners as well as the surface of the painting.

Mouldings

Today most towns have small framing shops in which a vast array of frame mounts and mouldings are available. Some of these shops will sell the prepared mouldings, and will make frames of your choosing from the stocks they have available. Always look carefully at what is available within the context of the painting you want framed. The sample display of moulding sections can be misleading. Note the ready assembled frames on display, they will probably be more helpful in guiding you toward a decision.

An alternative place to purchase mouldings would be a good wood supplier where raw sections should be available, though not in many

abundance of patterns. Some do-it-yourself centres may be able to order mouldings. Another possible source of supply is old junk shops, markets or auction rooms. Many hardwood frames with excellent mouldings are available at relatively small cost, though gilt and maple tend to be expensive at present. Finally you could purchase prepared wood and construct a frame from it. By far the simplest solution is to have the work framed professionally, and many artists work closely with their framer. This can be expensive depending on the ornateness of the moulding chosen.

Making your own frames

Sometimes a professionally made frame can be disappointing. The home-made article often has a pleasing simplicity and looks instinctively right where the professional job seems pretentious and ill-chosen.

To make your own frames you will need the following tools (most are probably readily available in the average household). You'll need a tenon-saw, screwdriver, tapping-hammer, drill and bit, countersunk bit, Stanley knife, pencils, screws, nails, picture nails, wood, glue, bevelled straight edge or thin steel ruler. The key pieces of equipment are a clamp used in conjunction with a mitre box which should guarantee the perfect cutting of 45° angles. Lastly you'll need some thin slats of wood and some gum or masking tape. Before deciding on the type of frame you want, remember that it will include a sheet of glass; any work carried out in the traditional watercolour medium is highly vulnerable to damage, particularly from damp. The size and nature of the work will to some extent influence your choice of frame. As a rule the larger the work the simpler the frame, for the work should have sufficient scale for it to exist in the average domestic space and be viewed comfortably without a large frame. If a work is tiny however, it can be completely lost on a wall, particularly if competing with other paintings, so the frame should have sufficient impact to attract scrutiny while at the same time being sympathetic to the work. The subject of the painting will be another deciding factor. For example it would be unwise to place a bright ornate frame around a very dark small painting: you would see nothing but the frame.

Mounts

Frames are usually used in conjunction with cardboard mounts. The mount has a dual purpose; firstly it provides a visually compatible surround for your work, secondly it separates the painting from the glass facing. There are certain rules to observe when cutting a mount: the side panels should always be the same size or slightly narrower than the top panel, while the bottom panel should be between a quarter and a third as large again as the top. If the mount were cut symmetrically

there would be an optical illusion that the bottom section was thinner than the top. Mounts are traditionally cut with a bevelled edge, however if you consider a square cut mount to be the ideal for a particular image do not hesitate to have it. Consider carefully, in relation to the size of the painting, how substantial a mount you require. Remember the mount needs to give support to the painting so the cardboard frame should not be less than 5cm (2in) wide at any point. The colour of the cardboard also influences how much mount you will want on view.

Cutting a mount

You will need to cut the aperture fractionally smaller than the painting to ensure a crisp divide between mount and painted surface. Assuming you have a cardboard mount 52.5cm (21in) by 40cm (16in) and a painting 37.5cm (15in) by 30cm (12in) subtract the painting measurements from those of the mount height. 52.5cm–37.5cm (21in–15in) = 15cm (6in); 40cm–30cm (16in–12in) = 10cm (4in).

Thus the side measurements are a fraction over 5cm (2in) each and working approximately on the basis of the top being a third to a quarter smaller than the base split the 15cm (6in) in a ratio slightly over 6.3cm (2½in) to 8.7cm (3½in). Mark out these measurements carefully on the facing side of the mount; place it on a soft cutting surface, take the steel rule, align with the measurements making sure the rule covers the actual mount, and cut holding a sharp Stanley knife at an angle of approximately 40° to 45°. Be careful when approaching the end of a straight run not to overcut, thus ruining the mount, but do not hesitate along the cut. Having cut the straights pick up the cardboard, insert the knife, gently cutting the remaining corner sections. Any fine shreds of cardboard can be removed with a fine sandpaper gently rubbed along the inside edge. Remove any plot marks with a kneaded eraser. You will find it impossible to cut straight through if it is thick. Always exert an even pressure, do not force the knife.

Even when cutting a square rather than bevelled mount, always cut from front to back, as a slight burning occurs on the back edge no matter how careful you are when cutting. Don't hesitate to break up the plane of the mount with lines drawn in ink or watercolour if the ink is too dominant (see fig. 1). Attach the painting to the back of the mount with masking tape, then back the mounted painting with another piece of cardboard of identical size to give added rigidity and protection to the back of the painting. It is now possible with the dimensions of the mount established to construct a frame to fit.

Constructing a frame

First, carefully check the dimensions of the painting. All too often inaccurate measurement can mean additional expenditure on mouldings.

Fig. 1 Breaking up the planes of the mount with a line

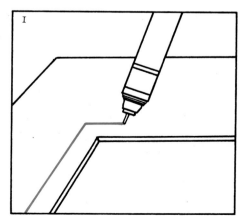

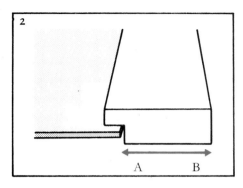

Fig. 2: Determining the length for the mouldings
Fig. 3: Support corners which are not in the clamp with pieces of wood
Fig. 4: Tacking the mounted painting onto the inside back edge of the frame

To ensure perfect joins, all the mouldings must be cut at an angle of 45°. When using the mitre block, saw gently because any unusual force could dislodge the saw from a true vertical and present real problems when joining. The lengths of the mouldings are determined by two factors, the dimension of the card plus twice the width of the moulding. This does not mean the total width minus overlap (see fig. 2). Thus you have a length of cardboard × 2 AB.

Cutting the mouldings

Cut the mouldings square first then cut the 45° angles. To join use a strong wood glue and slender panel pins [picture nails]. Apply the glue then, using the mitre clamp, grip the two pieces of frame together tightly. Drill a hole through one piece and partially into the other, knock home a nail and repeat on the other section making sure you do not allow the nails to collide. Remember the drill bit needs to be fractionally smaller than the nail to ensure a rigid joint. Under no circumstances run nails directly into the wood, or you will probably split it. Proceed with the three subsequent corners in the same way. Always support corners not in the clamp during the construction with pieces of wood of the same thickness as the base of the mitre clamps, otherwise the tension caused by the weight of the frame could open up the freshly glued and nailed joints (see fig. 3).

Framing under glass

The best protection for any painting is certainly glass, and this means the work has to be mounted first. There is a wide range of glass available, including a non-reflective variety, which shows the work most clearly.

Finishing the mouldings

If constructing a large frame that has a good deal of pliability it will be necessary to lay several pieces to support the straights as well as the corners while joining is in progress. When the glue is dry, countersink nails and use a commercially available filler to fill the small holes. Any surplus glue oozing from the joints should be wiped away while still wet with a clean damp rag. If your cutting has been inaccurate try to align the front face and fill in the gaps at the back where they will not show. Trying to camouflage the front can be difficult.

When thoroughly dry place the frame down on an old blanket to avoid damage to the facing surface. Slot in the piece of picture glass (today there is a non-reflective glass on the market) which should be fractionally smaller than the frame inset to allow for any movement in the frame. Clean thoroughly with a rag soaked in methylated spirit which will remove any grease and dirt; polish with a clean rag and place the mounted painting into the frame. Fix in place with 2.5 cm (1 in) panel pins

[picture nails] tacked into the inside back edge of the frame (see fig.4). Complete the procedure by taping over the nails, completely sealing the gap between cardboard and frame. As a further protection against the penetration of damp, glue heavy-duty paper over the back of the frame. This makes the back secure and keeps out dust. The simple moulding suggested here will be relatively cheap and visually attractive.

Clean the front of the glass and the job is complete except for actual hanging. Fixtures for hanging will be discussed later in the chapter. An additional feature used in framing is the inset (or slide) which is simply an inner frame which slots into the main structure. Insets are constructed of wood but are decorated in a variety of ways ranging from gilding through to velvet. However they often provide a pleasing visual contrast between painting and outer frame.

Constructing an inset

Should you be unable to purchase insets from a framer you can make your own, though with some difficulty. Use a thin hardwood 2.5cm (1in) by 1.25cm ($\frac{1}{2}$in) with a 45° bevel on the edge, measure accurately then cut at 45° as with the frame, and sand thoroughly. Lay several pieces of newspaper down on a perfectly flat surface. Glue the joints, press together with the face upwards, remove all surplus glue and allow to dry for 24 hours. When dry lift up the complete inset and tear off any newspaper stuck to it. Any remaining lumps can be cut off with a Stanley knife and sanded with fine sandpaper. Prime and paint it whatever colour you require—something fairly neutral, or the critical judgement of colours used in the painting could be seriously upset.

Decorating the inset

The raw mouldings purchased direct from a wood supplier are usually in need of a thorough sanding before any surface treatment. If the wood is of good quality it can be stained with transparent pigments—a thinned acrylic paint would be excellent for this purpose. The most suitable shades would be raw umber, burnt umber, raw sienna, ochre or a mixture depending on the colour required. The fast-drying acrylic allows for several coats of thin paint to be applied quickly. If you are not satisfied with the matt result then a coat of varnish could be applied. This would enrich the natural grain of the wood. Here you might choose to experiment with proportional mixes of gloss and matt varnish, or simply use a commercial stainer. Having sealed the wood you might explore the possibilities of stippling. Alternatively, try out plain emulsion finish or the high gloss lacquers.

Other frames

Gilded frames are always popular and certainly not impossible to

produce, but some specialized knowledge is necessary for their construction. If you make your own frame from prepared wood using a 5cm (2in) by 2.5cm (1in) or 5cm (2in) by 1.25cm ($\frac{1}{2}$in) frame as a base you could ornament it in a variety of ways by using different styles of beading and battening. These ideas are time consuming but worth considering particularly if you are good at carpentry.

A large number of superbly designed aluminium framing kits with a variety of finishes are available. They are rigid and have a simple right-angle locking system with screw attachments that hold the frame under any circumstances. Another recent innovation in this market are the shallow plastic box frames. These frames give excellent protection and hand-made papers without mounts look superb when secured to the back base. They can be, however, rather expensive.

Wall attachments
For the average-size framed painting, simple screw eyes inserted into the wood frame on either side at the back, and one picture hook will have sufficient strength. Picture hooks with steel pins can be purchased in any local hardware shop. They are either single or double pin. If screw eyes seem unsatisfactory there are alternatives such as the screw with ring attachment or ring with triangular plate. The triangular plate attachment has three screws and its strength makes it useful for heavy paintings. Unless you have a custom built rail with aluminium rods on your wall the most satisfactory support for heavy paintings are heavy-duty screw eyes. Tie a double length of heavy nylon cord between the two eyes, tensioning as required. With such weights an ordinary picture hook will be useless but a couple of 7.5cm (3in) screws set at a downward angle of 45° or 50° will take most weights.

Storing unframed paintings
You will not be able to frame all your paintings even if you should want to. Cost is one factor governing this, wall space is another, so some adequate storage is vital. The ideal place would be an architect's plan chest, but they are expensive and bulky. The alternative is a portfolio, though you should mount the paintings first. Portfolios come in a range of sizes and types from the cheapest cardboard ones to rather sophisticated plastic ones with individual plastic envelopes for added protection. The plastic range is probably the wisest buy, giving excellent protection against dust and having the added advantage of a handle, making them easy to carry. The size required will depend on the scale of your work but buy a size which will accommodate a fairly wide range of your paintings. Should you choose to purchase a cardboard folio make sure it has interior flaps to help stop damp or dust from penetrating the folio.